AURORA

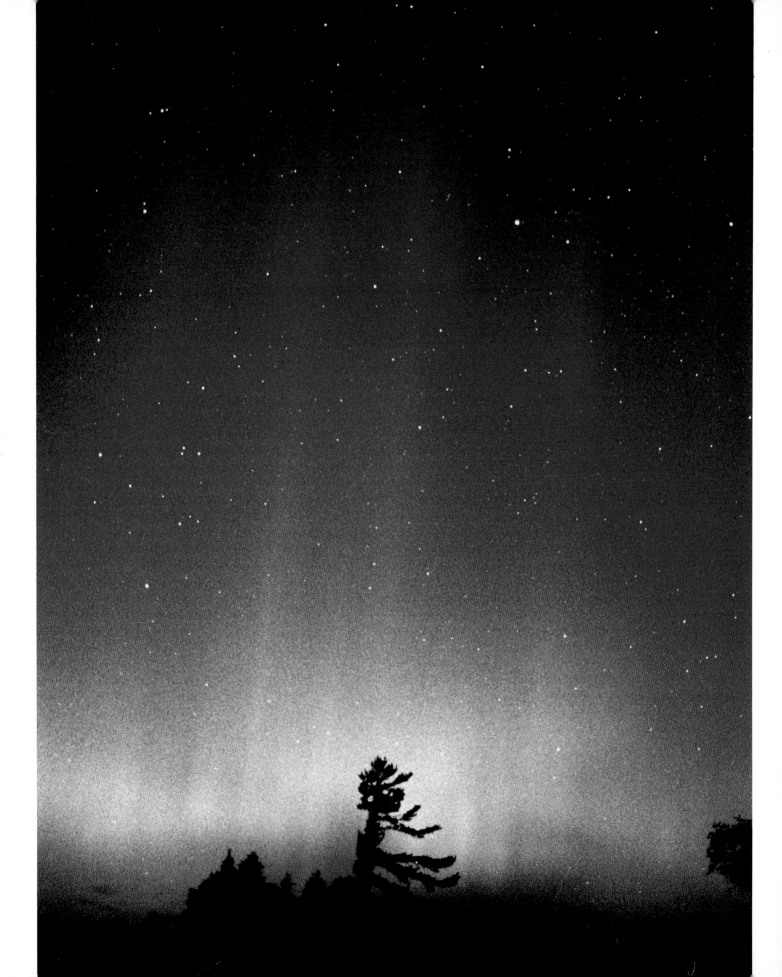

AURORA

THE MYSTERIOUS NORTHERN LIGHTS

CANDACE SAVAGE

FIREFLY BOOKS

A FIREFLY BOOK

Published by Firefly Books (U.S.) Inc., 2001

First Printing

Cataloguing in Publication Data
 (Library of Congress Standards)

Savage, Candace, 1949-
 Aurora : the mysterious northern lights / Candace Savage. – 1st ed.
144 p. : photos. (some col.), maps ; cm.
Includes bibliographic references and index.
Summary: Illustrated history of how various cultures have explained the aurora (northern lights).
ISBN 1-55209-583-5 (pbk)
1. Auroras – History. I. Title.
538 /.768 21 2001 CIP

Published in the United States in 2001 by
Firefly Books (U.S.) Inc.
P.O. Box 1338, Ellicott Station
Buffalo, New York 14205

Editing by Shelley Tanaka
Front cover photograph by Jack Finch
Frontispiece photograph by Terence Dickinson
Front cover design by Jim Skipp
Interior design by Barbara Hodgson
Map and diagrams by Fiona MacGregor
Printed and bound in Singapore by C.S. Graphics Pte. Ltd.

Quote from "The Ballad of the Northern Lights" by Robert Service used by permission Estate of Robert Service.

For Diana, as ever

CONTENTS

Acknowledgements / 9

1 Airy Nothings / 13

2 Myth and Mystery / 25

3 Lumine Boreali / 45

4 The Magnetic Crusade / 69

5 The Last Frontier / 93

6 Auroral Glories / 115

Notes / 133

References / 136

Index / 141

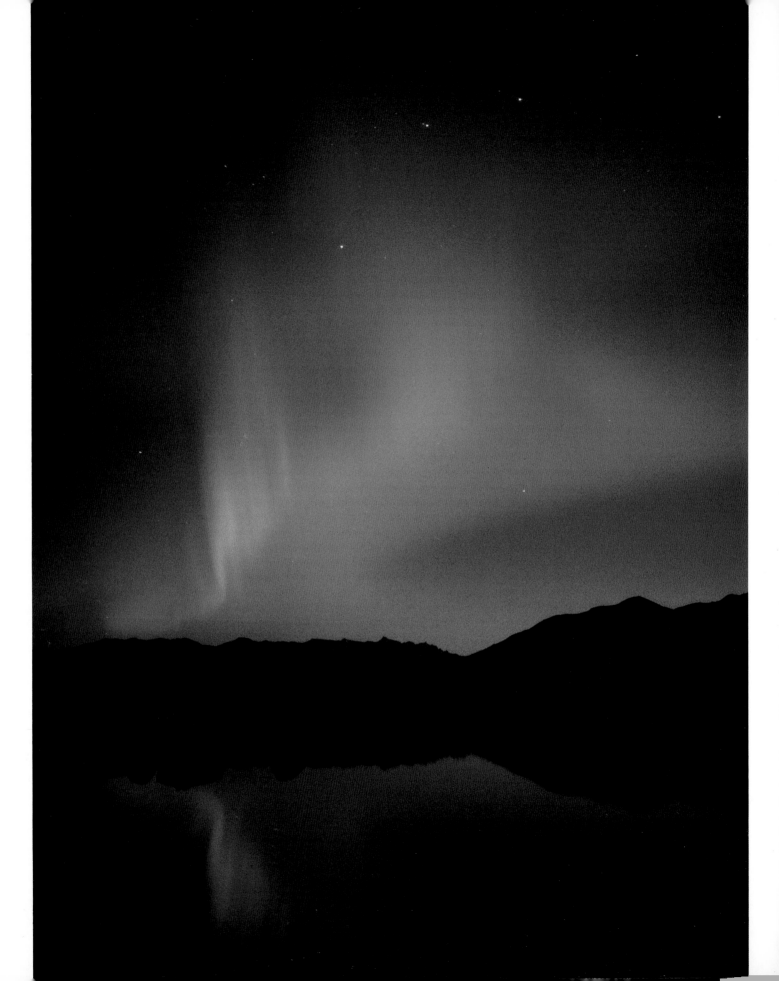

Five years ago, when I began work on this book, I was a physics illiterate. Although I could recite a few alphabetic mantras—$f=ma$, $e=mc^2$—they represented almost the sum of my knowledge. If this is no longer the case, it is a credit to all the people who have helped me with this project. They include auroral physicists Don McEwen of the Institute of Space and Atmospheric Studies at the University of Saskatchewan and Gordon Rostocker of the Canadian Network for Space Research at the University of Alberta. Each has gone out of his way to explain fine points of auroral science and to offer encouragement. Together with science historian Larry Stewart of the University of Saskatchewan, they also provided expert reviews of the text and made many comments and suggestions that greatly strengthened the book.

ACKNOWLEDGEMENTS

I am also grateful for the patience, good humour and skill of the researchers and librarians who assisted with my work. The staffs of the Yellowknife Public Library, the GNWT Library and the Otto Schaeffer Health Sciences Resource Centre—all in Yellowknife—were exceptionally generous with their time and resources. So were the librarians at the University of Saskatchewan library in Saskatoon—notably Mary Dykes and Neal Richards in Interlibrary Loans, who cheerfully dealt with all my requests for obscure documents. Melissa Ladenheim found answers to many questions in the folklore collections of Memorial University in St. John's, Newfoundland, and Elizabeth Wolfe of Saskatoon provided efficient assistance with illustrations.

Finally, it is a pleasure to acknowledge my debt to the friends and colleagues who believed in this project through its long genesis. As ever, they include my publisher Rob Sanders and editor Shelley Tanaka. Thanks are also due to Richard Clarke, for discussions that guided my initial approaches to this subject. In the later stages, many of my ideas took shape in conversations with Keith Bell, over innumerable bowls of soup at Calories. My daughter, Diana, was with me from beginning to end, buoying me with her high spirits and her confidence.

OPPOSITE: *Heavenly reflections—a shimmering aurora ripples beneath the stars of the Big Dipper, Knik Valley, Alaska.*
DAVE PARKHURST

OVERLEAF: *Dancing banners of auroral light stream above the snowswept streets of Churchill, Canada.* NORBERT ROSING

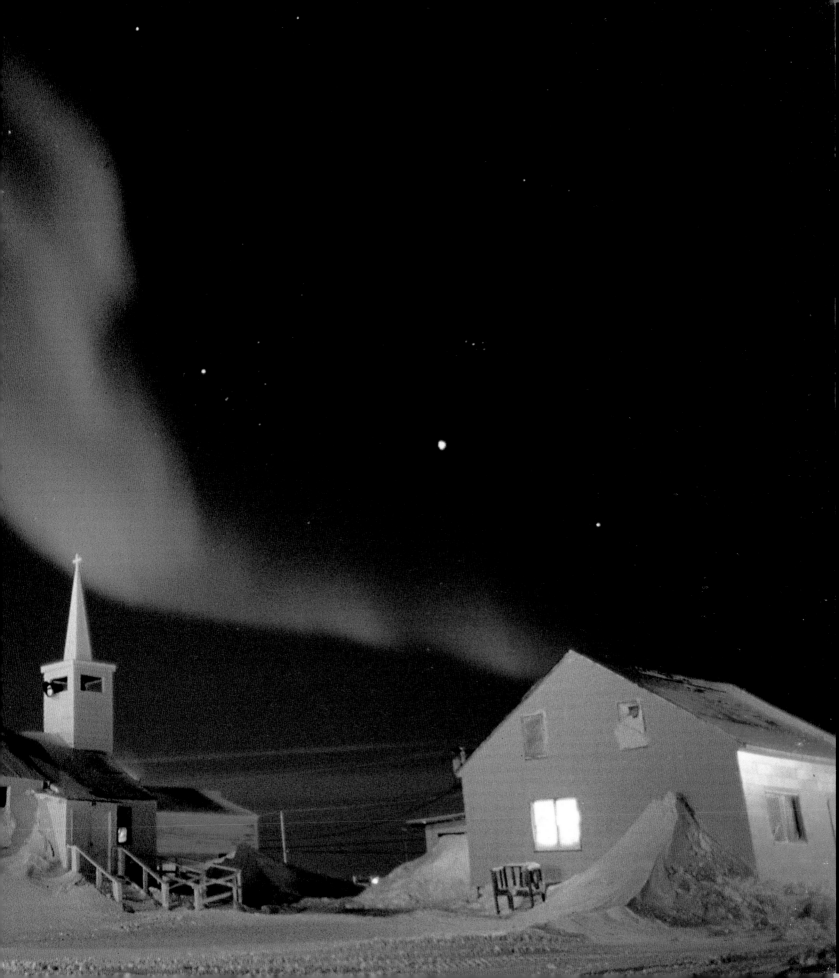

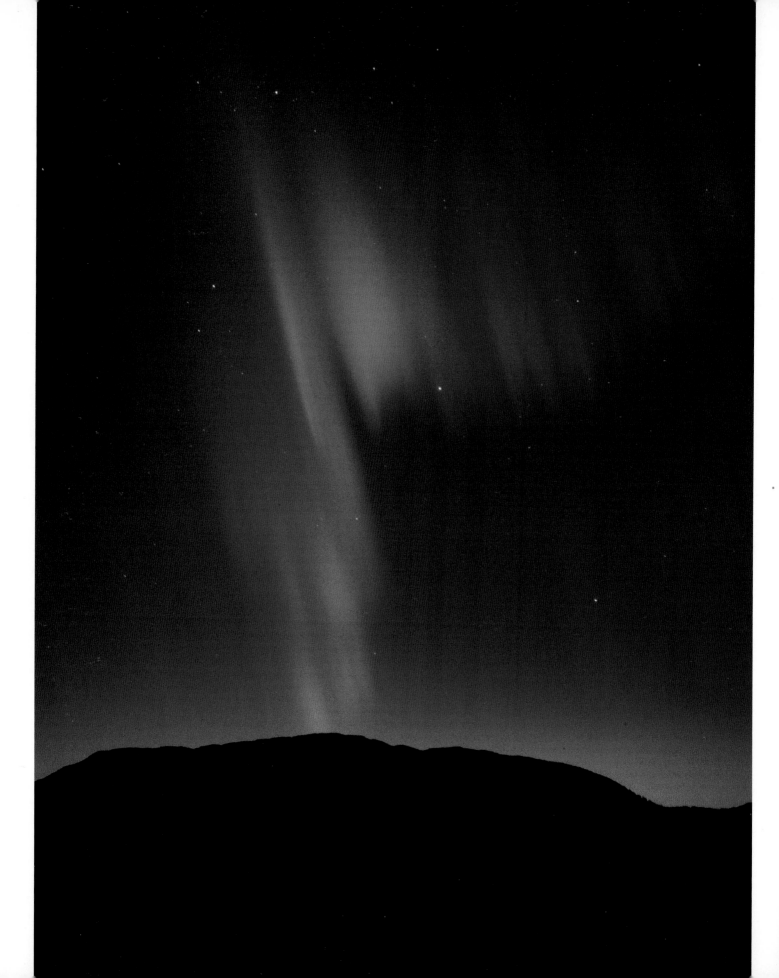

It is dark. Not the phony dark of a modern, overlit city, but true dark and cold. The yellow glow of camp fades quickly behind us, eclipsed by the forest and the dense night.

Two vague forms, our silhouettes muffled with winter clothes, we shuffle out of the spruce woods, through a thicket of willows and onto the surface of a small lake. A little distance into this clearing, my companion stops. "Look," she says quietly, waving a mittened hand. "Look up."

Ribbons of frosty breath stream from our upturned faces. Far above, ribbons of soft greenish light stream across the sky. Aurora borealis, the northern lights.

From horizon to horizon, misty dragons swim through the heavens. Green cur-

CHAPTER 1 AIRY NOTHINGS

tains billow and swirl. Fast-moving, sky-filling, tissues of gossamer. Through them in the farther distance, we can see the familiar pinpoint outlines of star patterns: Great Bear and her son, Little Bear; sinuous Draco; exact Cassiopeia; Polaris, the hub.

Apart from the hush of our breathing, nothing can be heard. We lean our heads together and speak in whispers.

We are grown women, my friend and I. Indeed, if the sombre truth is to be told, we are middle-aged—well educated, well travelled, well read; and here, near the shore of Great Slave Lake in the Canadian territories, the northern lights are a privileged commonplace. We have often seen them before. Yet we stand transfixed, in the middle of the night, in the middle of a snowy pond, watching the aurora dance overhead.

By rights, we humans ought to live in constant wonderment, amazed by every star, cloud, tree, leaf, feather, fish and rock. Amazed by the supreme improbability of our own intricate existence. But except for a gifted few (artists and mystics), we lack the stamina for so much mystery. It takes a shock—a sudden burst of beauty—to wake us to the wonder of our reality.

What power brings the sky to life with these soft, streaming curtains of light? How can they write themselves across the night and then vanish, without a trace, into the

OPPOSITE: *A multicoloured streamer of northern lights cascades down the evening sky, Hawkins Island, Prince William Sound, Alaska.*

DAVE PARKHURST

darkness? Where do they come from? Where do they go? What prompts them at one moment to hang quietly over the horizon, an unobtrusive arc of whitish light? At another, still formless and diffuse, to flutter in the zenith with a steady, flashing pulse? At yet another to unfurl themselves in rushing, swirling bands of green and pink that eddy, flow and crack the whip in the silence?

Does all this heavenly glory have some deep meaning? What do the lights have to tell us about the mysterious stardust universe into which we are born?

Around the world—in Canada, the United States, Scandinavia, Russia, Australia and Japan—researchers are seeking answers to these and other questions with persistence, creativity and a welcome touch of humour. In Alaska, for example, auroral studies are centred at a place called Poker Flats, a raffish collection of barracks and sheds that slouches in a deep, forested valley outside Fairbanks. Near the door of the main building, a large, official-looking notice announces the purpose of the facility. This is, the sign declares, the *Center for the Study of Something which, on the face of it, might seem trivial, but on closer examination takes on Global Significance.*

There is more than a lick of truth in this playful pronouncement. Under the gaze of modern science, the polar lights have turned out to be even more wondrous than we had imagined. Seen from space, the aurora is revealed as two broken rings of light, each about 4000 kilometres in diameter, that hover over the polar regions of the earth. What's more, these haloes appear simultaneously and symmetrically in both the northern and southern hemispheres. While people in the North are watching a display of northern lights, a mirror-image array of southern lights is flickering above the heads of penguins in Antarctica. Day and night, summer and winter, auroras cavort above the earth at heights of 100 to 1000 kilometres. Powered by particles from the sun, shaped by the earth's magnetic field and coloured by gases in the upper atmosphere, they bear witness to the immense, invisible processes that animate our home region of the universe.

To our eyes, the cosmos appears to be a vast emptiness. But the aurora is there to prove otherwise, for if space really were uniform and uneventful, the lights would never shine. In the neighbourhood of earth, the darkness is buzzing with unseen activity. It is as if we lived inside a huge electromagnetic pinball machine, in which invisible particles zoom around an immaterial race course, accelerating wildly at certain points, looping out of the action at others, and occasionally scoring by zapping towards earth and producing bursts of auroral light.

When we venture out on a clear night and gaze into the sky, we do not detect any of this frenzied activity, because the processes that create the aurora are beyond the reach of our senses. We cannot taste a proton, smell a magnetic field or hear particles streaming in from space. An electron, which weighs only 10^{-30} kilograms, is too small to see or feel, yet electrons are the heroes of modern auroral physics. Conversely, a particle flight-path of 600 000 kilometres through the earth's magnetic field is so large that it strains our powers of conception. Were it not for the lights themselves, we would have no direct way of perceiving or intuiting what is happening Out There in the near-space environment.

The polar lights mark the threshold between the visible and invisible universe. So it is not surprising to discover that they have stimulated the imaginations of some of the world's great scientists: Galileo Galilei, René Descartes, Edmond Halley, Anders Celsius, Benjamin Franklin, Alexander von Humboldt and many others. The consecutive attempts of these thinkers to account for the aurora in terms of underlying physical forces form an interesting, if sometimes antic, history to which we will return in subsequent chapters.

But scientists were not the first or only people to turn their attention to the aurora. Thousands of years before science was invented, people were already gazing up at the night sky and pondering its significance. Like the scientific explanations, folkloric accounts of the aurora invoked the fundamental forces of the universe, in whatever guise those forces were known to local cultures. Where science now traces the pathways of invisible particles in ineffable magnetic fields, members of traditional spirit-filled cultures thought they saw the progress of angels, departed ancestors and supernatural creatures. Which explanations are most accurate? Most valuable? Most fun to know? You are free to decide for yourself as the story unfolds.

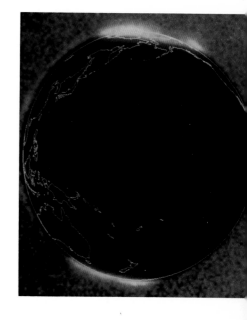

This stunning photograph shows the earth crowned by the northern and southern aurora. The picture was captured in 1982 by cameras aboard the Dynamics Explorer satellite, from a height of about 20 000 kilometres. Coastlines are indicated in green, with Asia and North America at the top and Australia and New Zealand at the bottom. Because this is an ultraviolet photograph, it shows the aurora in its true position but not in its true colours.

COURTESY OF L. A. FRANK, UNIVERSITY OF IOWA

WHERE ON EARTH?

The aurora is never absent from the earth. Every hour of the day, every day of the year, it works its luminous magic over both the northern and southern hemispheres. But if it is always present, why is it so rarely observed? Why do most us go for months, or even years, without a chance to enjoy its splendour?

The answer is that the aurora spends most of its time around the ends of the earth, where it dances mainly for the pleasure of penguins and polar bears. Where the aurora is common, humans tend to be scarce. In the northern hemisphere, for example, the best places to view the lights lie within an auroral zone that encompasses such metropolitan centres as Barrow, Alaska; Yellowknife, La Ronge and Goose Bay, Canada; Tromsø, Norway; and Nordvik, Russia. Along this band, the lights can be seen on virtually every cloudless night from autumn to spring. (In the summer, the aurora is blotted out by round-the-clock sunlight.)

Fortunately for those of us do not live in such favoured locations, the aurora often spills out of its homeland to brighten the skies of neighbouring regions. What happens is that the auroral ovals—the haloes of auroral light that encircle the poles—actually expand, so that displays spread out towards the equator. Small expansions of the ovals are quite common; large ones are very rare. Thus, people who live close to the auroral zone can hope to see the lights fairly often, whereas those who live farther away will be less fortunate.

For example, at the latitudes of Coppermine, Northwest Territories, and Saskatoon, Saskatchewan, the probability is about 60 per cent, which means that some sort of display could be noted two or three times a week (cloud cover and twilight permitting). By contrast, the chance of seeing an aurora near Los Angeles is about .5 per cent, which means it could happen, at the most, once or twice a year.

Because the peak of auroral activity misses the population centres of Europe and Asia, displays are rare over the major cities of those continents—Oslo and Edinburgh enjoy them about one clear, dark night in 10; Moscow, one in 35; Paris, one in 70; Munich, one in 100; Rome, one in 1000; and Tokyo, one night in 10 000 (about once in thirty years).

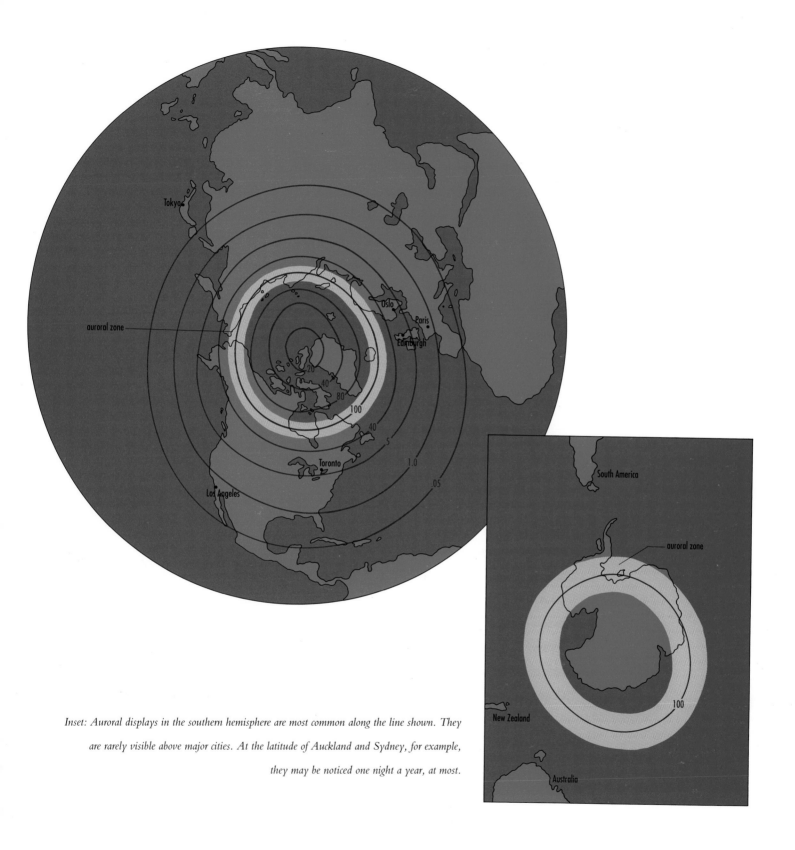

Inset: Auroral displays in the southern hemisphere are most common along the line shown. They are rarely visible above major cities. At the latitude of Auckland and Sydney, for example, they may be noticed one night a year, at most.

THE RIGHT TIME

• Because auroral light is as faint as starlight, the aurora is not visible in the day or during the long twilights of summer. (It is also washed out by streetlights, so serious aurora enthusiasts keep their watch out of town.)

• Auroras that appear just after dark are usually not very exciting. They generally resemble cirrus clouds that have been silvered with a soft, slow-shifting light. But these quiet auroras are still worth noting, because they often set the stage for a spectacular light show that will develop a few hours later.

• In general, auroras are most spectacular in the hours around midnight.

• If you see a brilliant aurora one night, there is a good chance that you will be in luck the following night as well. This is because the cosmic conditions that are right for the lights generally last for several days in a row. Vivid auroras also tend to recur at 27-day intervals, so mark your calendar and check again.

• Dramatic auroral displays tend to be slightly more common around the spring and fall equinoxes than at other seasons. They are also a bit more likely to spill out of the auroral zones at these times, bringing their pleasures to people in mid-latitudes.

• Although the aurora is always present, it undergoes a more or less regular ebb and flow of vitality. At the low point of its cycle, it is basically confined within the auroral zones. But over the succeeding five or six years, it gradually builds to a peak of activity, with many dramatic displays and frequent excursions into mid-latitudes. Then, over the following five or six years, it subsides again. The next peak is expected in or around the year 2002 (with others to follow at roughly eleven-year intervals: 2013, 2024, etc.).

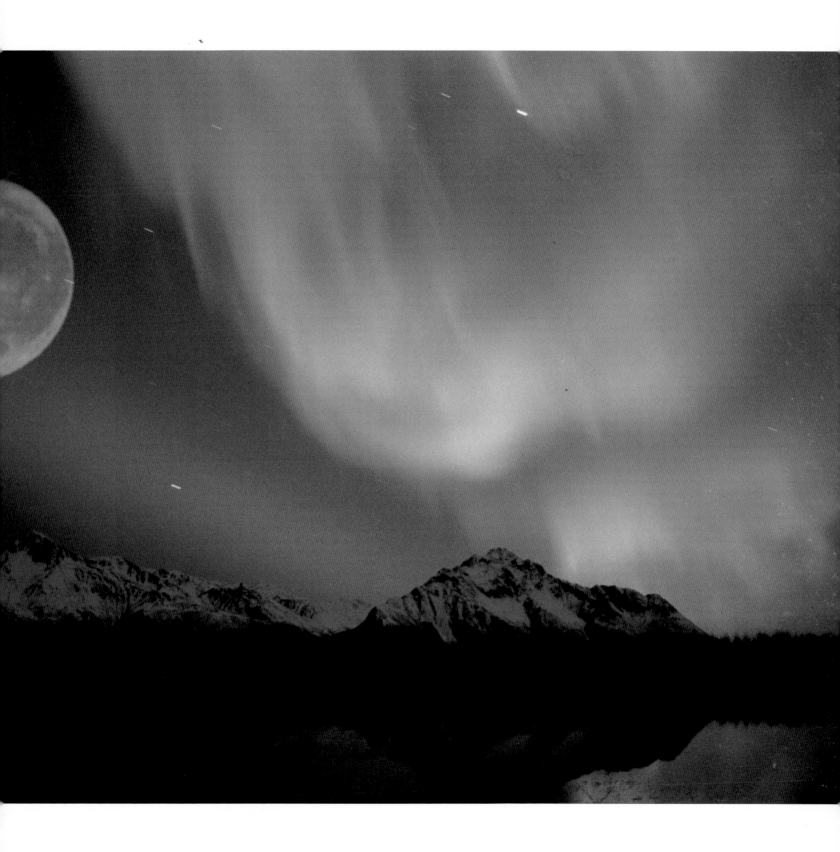

PREDICTION SERVICES

Some people improve their chances of seeing the aurora by obtaining daily forecasts from the Space Environment Sciences Center in the United States. This is a research station that collects minute-by-minute data on the earth's magnetic field and uses this information to predict auroral activity. A quiet magnetic field means a quiet aurora—unspectacular forms that are only visible in the auroral zone. An active magnetic field means more active displays—dramatic outbursts that extend over large parts of the globe. The greater the magnetic disturbance, the greater the auroral activity that can be expected.

Because the auroral system is very changeable, forecasts are only good for a few hours after they are issued. Even within these limits, they are not 100 per cent reliable. But if you especially want to see an aurora, the Center's data can help you to be in the right place at the right time. Bulletins, updated four times a day, are available via recorded message (303-497-3235), modem and short-wave radio. The most useful indicator is the K index, which summarizes geomagnetic activity in the previous three hours. Low ratings (for example, a K index of 1 or 2) suggest that the aurora will be quiet. Successively higher values correlate with auroras that are successively more active. For more information, and to find out which K value is associated with auroras at your latitude, you can write to the Space Environment Sciences Center, National Oceanic and Atmospheric Administration, 325 Broadway, Boulder, Colorado 80303-3328 U.S.A.

OPPOSITE: *As the blue light of dawn washes over O'Malley Ridge in Chugach National Park, Alaska, a frosty swirl of auroral light pulses over the snow-clad mountains.*

DAVE PARKHURST

AN AURORAL DICTIONARY

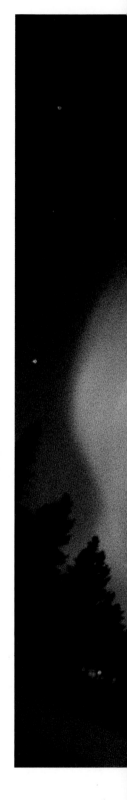

In the early days of auroral research, scientists tried to make sense of the lights by distinguishing different "types" by sight. Today, researchers are much more interested in the invisible processes that create the aurora than they are in its visible appearance, so the old classification system has been set aside. But the terminology that was developed in earlier times can still help us appreciate and describe the varied delights of auroral forms.

Here is a brief lexicon of auroral terms:

arc: An evenly curved arch of light with a smooth lower edge that may extend from horizon to horizon (see page 91).

band: Similar to an arc, only folded or kinked on its lower edge (see page 23). Arcs and bands can be described as "quiet," "active," "streaming" (when a sudden increase in brightness passes horizontally along the display) or "flaming" (when sudden bursts of light appear at the bottom of the form, flare up to the top and disappear). They may also be "rayed" (made up of rays) or "homogeneous" (uniform washes of light).

corona: Rayed arcs or bands seen from directly underneath, so the light seems to beam out like a sunburst in all directions (see page 43).

patch: A small, cloudlike area of auroral light. Sometimes a patch will flash, or pulse (see page 20).

ray: A thin beam or shaft of bright light that hangs more or less vertically (see page 12). A ray is actually a tight curl, or eddy, of light seen from the side.

veil: A large, featureless expanse of light that sometimes covers the entire sky (see page 121). It may be white or, in exceptional cases, red.

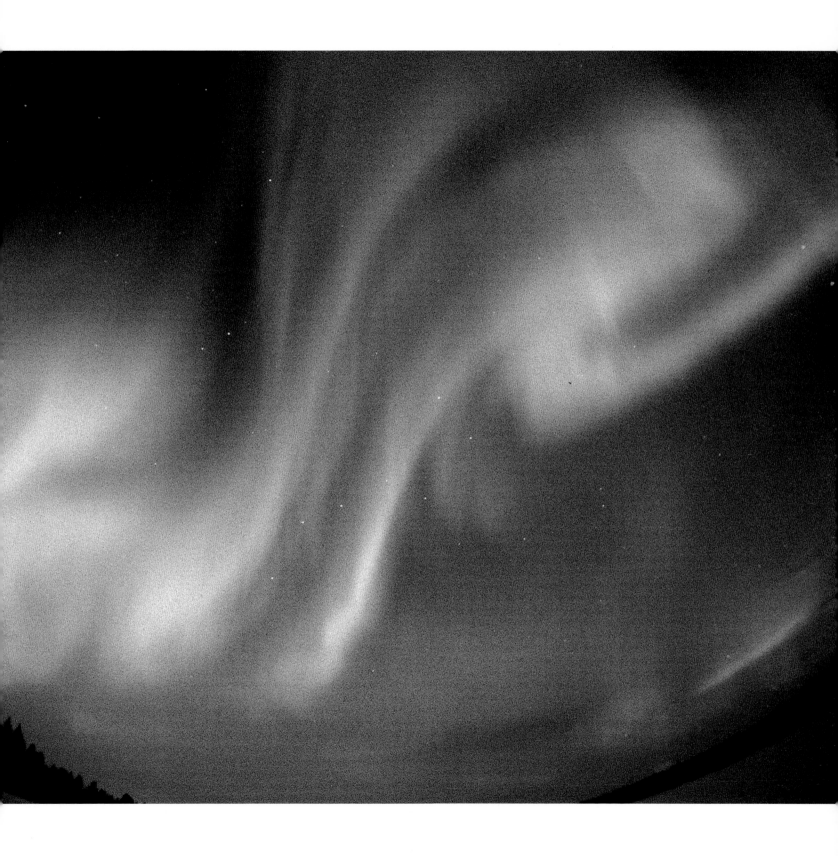

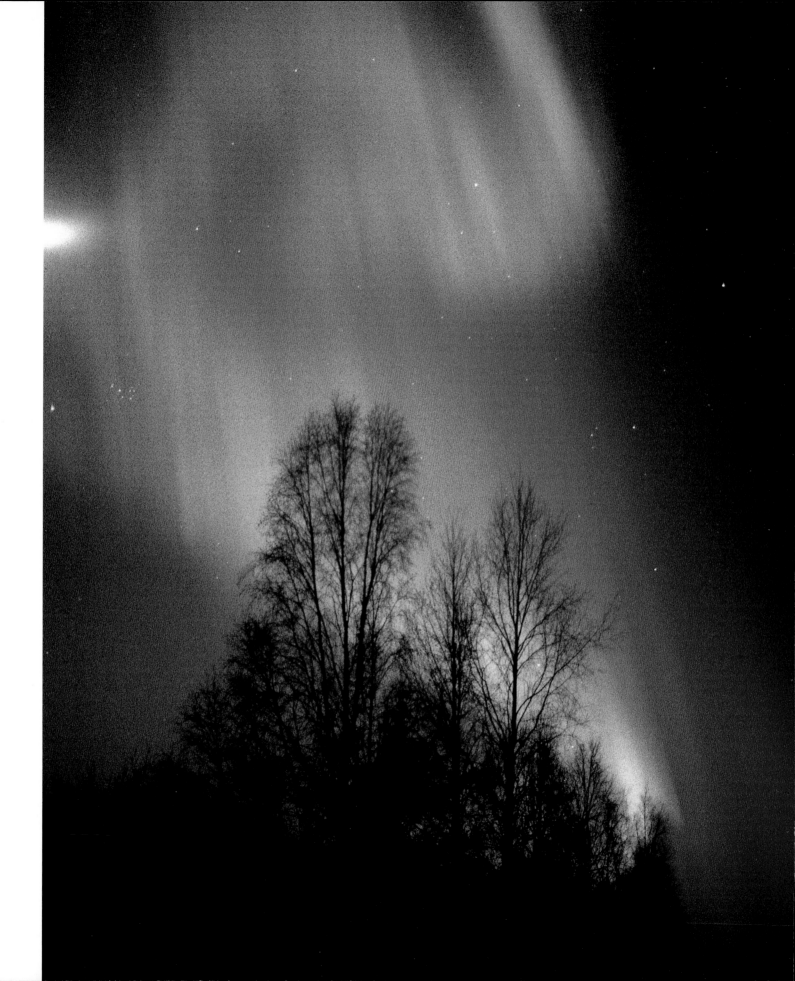

It was late, and my daughter and I were out for a bedtime walk through our neighbourhood. It had been months since we had seen the aurora, and suddenly there it was: shimmering curtains of vague luminance across the northern horizon.

We ran for home, jumped into our van and hurried out of town. At the end of a country road, we stopped, sprawled on top of our vehicle and stared out into the dizzying darkness. Above us, the sky was now etched with long white rays—a starburst of silvery threads that seemed to converge over our heads.

Time passed, and the rays dissolved into a pale, eerie light. Then, just after midnight, the whole sky began to throb with this cold radiance—north, then south, then north, then west—flashing on and off in an instant or surging across the darkness like gusts of frosty breath.

Before we came to this religion
They used to meet with
* strange things*
Not seen by ordinary people.
The land moved, the rocks
* moved.*
They used to meet with
* strange, strange things.*
—Inuit drum song

CHAPTER 2 MYTH AND MYSTERY

"They're scary," my daughter said. Yes.

The aurora is both wondrous and alien. In its presence, we may feel delight or dread or some uneasy mixture of conflicting emotions. These responses give us a living connection to the powers that are at work in the heavens. At the same time, our feelings offer us an important connection to other members of the human tribe. Through countless millennia, people have stood and wondered under the polar lights. In different places and times, our ancestors created radically different interpretations of what was going on. But their contradictory emotional responses seem always to have been much the same as our own.

On the one hand, the lights appeal to people with their loveliness. Under their spell, the universe may come to life with gaiety and benevolence. Thus, the Eskimos of the lower Yukon River in Alaska described auroras as the dancing souls of their favourite animals: deer, seals, salmon and beluga whales. The Finns were put in mind of magical "fire foxes" that lit up the sky with sparks that flew from their glistening fur. In a similarly joyful mood, the people of the Hebrides thought they could make out a tribe of shining fairies known as the "nimble men." To the Scots the lights were "merry dancers" and to the Swedes a polka, or folk dance. Old-timers in French

OPPOSITE:

He knew, by the streamers that
* shot so bright,*
That spirits were riding the
* northern light.*
—Sir Walter Scott, 1802

JACK FINCH

MIRROR-IMAGE MYTHOLOGIES

The folklore of the northern lights is more diverse than that of the South. This is hardly surprising, since the northern lights spend most of their time over parts of the earth that are, however sparsely, inhabited. The southern aurora, on the other hand, usually hovers above Antarctica and the polar sea, where virtually no one is around to observe it.

The only time the southern lights find an audience is when they flood northwards towards Australia and New Zealand. Here they have inspired a number of beliefs and legends that easily equal northern lore in their inventiveness. They are also remarkably similar to northern beliefs in their basic concepts. In Europe and North America, for example, various peoples have seen the aurora as reflected light from the torches or campfires of people far to the north. In the same vein, the Maori of New Zealand spoke of ancestral travellers who, long ago, voyaged far south by canoe and became trapped by cold and ice. Their descendants were said to have remained in that inhospitable zone, where they sometimes kindled huge bonfires that were mirrored in the night as *Tahu-nui-a-Rangi* (Great Glowing of the Sky). The Ramindjeri and Kaurna people of Australia imagined similar fires just offshore on Kangaroo Island, near Adelaide.

Sometimes the southern auroral flames were kindled by spiritual powers. Certain aboriginal people in northern Australia viewed the aurora as the feast fires of the Oola-pikka folk—ghostly beings who spoke to the people most directly during the Dream Circles (the time when children first met their guardian spirits). Only the elders dared to look at the lights and interpret their advice.

Among the Kurnai people of southeastern Australia, the aurora required no interpretation. To their eyes, the lights were an unequivocal and terrifying warning from the Great Man, Mungan Ngour, and a sign of his great wrath. According to Aldo Massola in his book on aboriginal culture, the Kurnai "were thrown into great confusion [when they saw the aurora]. . . . Everyone ran about shouting at it to go away, and the men swung their *bret*, or dead hand, towards it." The dead hand—the preserved member of a dead friend or relative—provided protection against supernatural danger. In the northern hemisphere, people seized by similar terror attempted to ward off auroral spirits with iron tools or knives.

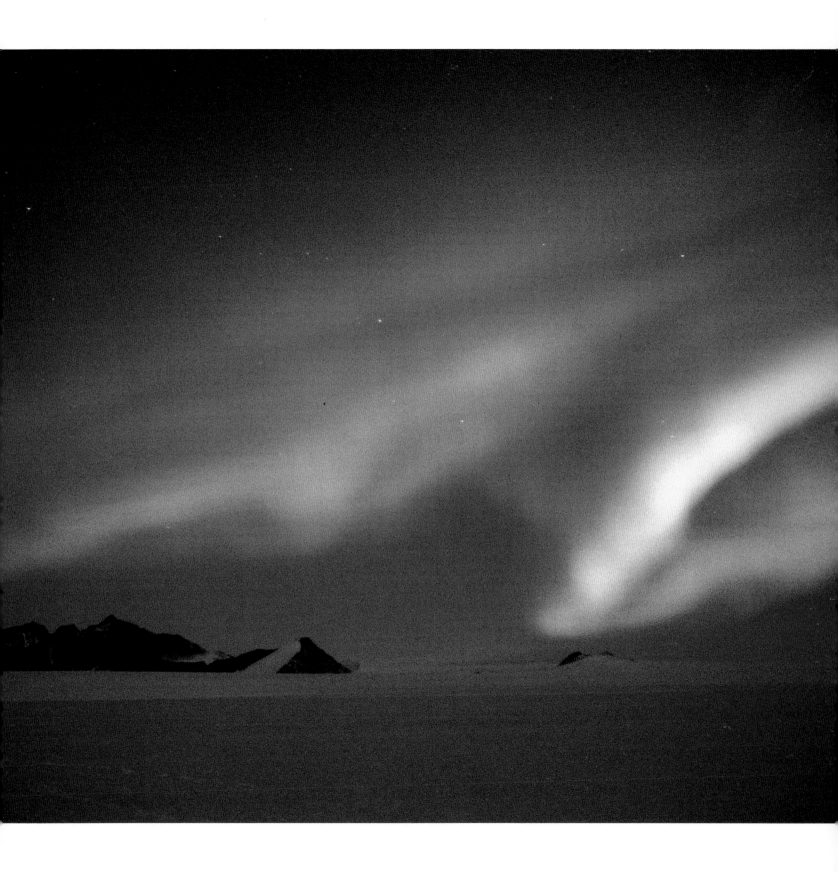

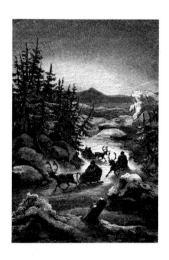

Canada knew them as "marionettes." A tale from Estonia imagines them as the glow from a celestial wedding, in which the horses and sleds of the guests all shine with a mysterious radiance.

In Scandinavia tradition has it that the lights are the final resting place for the spirits of unmarried women who busy themselves above the mountain Konnunsuo by making fires, cooking fish, dancing and waving their white-gloved hands. "The women of the North are hovering in the air," the Finns used to say, or "Sibylle is burning her woollen blanket." In a less decorous spirit, the Samis of Sweden sometimes addressed the aurora as "Girls running around the fireplace dragging their pants."

And if there are half-naked women up there, perhaps there will be childbirth. The Chuvash people of central Asia identified the lights as the god (or goddess) Suratan-tura (Birth-giving Heaven); it was said that the sky gave birth to a son when the lights rolled and writhed. Fittingly, this deity could be called upon to ease women through the pains of labour. There was also a suspicion in some cultures that the lights were connected to the life-giving mysteries of conception. The Lakota Sioux thought the aurora might be the spirits of future generations waiting to be born, and there is an old Chinese record of "the mother of the Yellow Emperor" who, in 2600 B.C., "saw a big lightning circulating around the Su star of Bei Don [in the Big Dipper] with the light shining all over the field" and "then became pregnant." To this day, dozens of Japanese honeymooners visit northern Canada each year, persuaded that children conceived in the spell of the lights will be fortunate.

The aurora has also been thought to enhance the fruitfulness of the earth. A Swedish tradition has it that "when the northern light is burning, the seed will be abundant." Some Nunamiut Eskimos believe that if the sky is divided in half by auroral displays, animals will be plentiful in the area the next day. Dene elder Alexis Arrowmaker says the lights are there to show hunters where they can find the most game. Similarly, Scandinavian fishing people used to interpret the lights as sunshine glinting off schools of herring in the northern sea and, hence, as a welcome omen of rich catches in the offing.

The power of the lights could also be invoked to cure disease. When Knud Rasmussen visited the Inuit of the central Canadian Arctic in the 1920s, he found the aurora to be "in great demand as a helping spirit for the best shamans." It was a basic

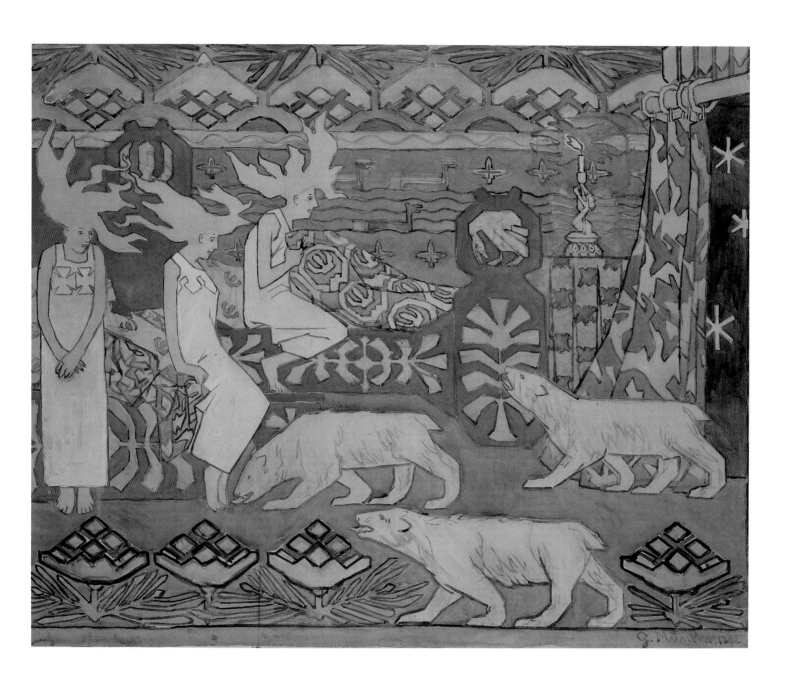

THE AURORA AND HUMAN HEALTH

In 1963 the prestigious journal *Nature* published a report by two American investigators, Howard Friedman and Robert O. Becker, which showed a statistical correlation between psychiatric admissions and "geomagnetic disturbances." These are changes in the earth's magnetic field that are often associated with brilliant and widespread aurora. According to these researchers, the results suggest that people are "significantly influenced . . . by external force fields. Attention is thus invited to a hitherto neglected dimension in the complexity of psychopathology specifically, and perhaps generally in all human behaviour."

A decade later, two medical researchers in the U.S.S.R. published the results of a similar study in which they found that people are more likely to have heart attacks—especially fatal ones—under conditions that also produce vigorous aurora. In 1976 another Russian investigator reported that more people die from certain kinds of heart conditions when the auroral (geomagnetic) system is active.

Then, at the annual meeting of the American Psychological Society in 1986, four researchers—Michael Persinger, Marsha Adams, Erlendur Haraldsson and Stanley Krippner—reported on the relationship between ESP and geomagnetic changes. Working independently of each other and with different methods, they all concluded that extrasensory perception is inhibited by geomagnetic disturbances.

Science is at a loss to explain these apparent effects, and skeptics write them off as coincidence, at best.

responsibility of all Inuit healers to make "spirit journeys" into the lights, to obtain advice about treatments and to rescue souls from death. As recently as the 1950s, a healer on Kodiak Island, Alaska, relied on the lights to cure heart ailments. A boy who experienced this procedure remembered that "his mother sent for a woman who held him up to the northern lights and then pulled something out of his chest." Unfortunately, we are not told if he was healed by this treatment.

But we do know of an instance in which the aurora provided religious guidance and spiritual healing to an entire community. It happened among the Lakota Sioux in 1805, when the people wished to revive an important ceremony that had been abandoned several years earlier. Performing the ritual correctly was a matter of life and death, and the leaders were not sure exactly what to do. So, as John Blunt Horn recalled in the early years of this century, the elders and shamans "said they would counsel and make medicine and talk with the spirits and find out about this thing":

They went into the council lodge and stayed there two days and two nights. . . . And many persons saw ghosts the first night. The second night the ghosts danced so that it was light like the moon (the Aurora Borealis). While the ghosts were dancing, the old men and the wise men and the medicine men came out of the council lodge and

An Inuit hunter contemplates the aurora in this nineteenth-century illustration from Narrative of the North Polar Expedition, *edited by C. H Davis, 1876.*

danced in a circle around it. Many saw ghosts dancing with them. So all were afraid and went into their tipis.

In the morning one of the old men called aloud to the people to come out of the tipis and look on the sun when it was rising. And all the people came out and stood looking at the sun, and while it was rising, the old man cried in a loud voice that the spirits were pleased, [and] that they had told them how to perform the ceremony . . .

And, indeed, after that, the ceremony was revived in a new form, following the auroral spirits' instructions.

Even Christians could sometimes benefit from the aurora's spiritual help. In 1397 a Russian monk named Kirill heard a voice urging him to establish a monastery. When he went to the window, he saw a great aurora radiating over the northern sky and pointing with its fingers towards the chosen location. Guided by this instruction, Kirill established the Kirillo-Beloszerskij monastery at White Lake, near Novgorod, a strategic location in which he and his community enjoyed both influence and wealth.

So it seems, in large ways and small, that the aurora can reflect the favour of heaven to humans watching below. The Ottawas of Manitoulin Island in Lake Huron expressed this thought in the form of a myth. According to a tradition recorded in the 1850s by Francis Assikinack, the lights are a message from the creator-hero Nanahboozho, who restored the earth after the Flood and then went to live in the North. Before he left, he told his people that he would always take a deep interest in their well-being. As a sign of his good will, he promised to light large fires that would glow against the sky and appear to the people as the northern lights. Thus, like the rainbow in the Old Testament, the aurora stands as a sign of harmony and trust between humans and their creator.

The Dogrib people have a similar belief—but with a crucial twist. According to their mythology, the hero Ithenhiela first laid out the landscape of northwestern Canada and then journeyed to his rest in the Sky Country. He is up there still and sometimes beckons to his people with long, gauzy fingers of light, calling them to the home he has found for them in the land beyond the sky. But it is a decidedly double-edged message, since to join him you first have to die.

That's the rub, in life and in auroral traditions. *You have to die,* and people have long harboured a suspicion that the lights are somehow implicated in this tragedy.

Indeed, the whole of the North has often been mythically linked with death and dying. As mythologist Uno Holmberg points out, since the night is the time when spirits move about, it follows "that the underground world of the dead lies towards the sunset, or towards the dark north." In old Scandinavian texts, the road to Hel always leads "downward and northward," and the way is barred by a "trembling road" and a "flaming whirlpool"—both possible references to the aurora at the boundary between the worlds. "I seemed to be lost between the worlds, while around me burned the fires," laments the shaken narrator of the Hervarar Saga. And while the cold flame of the aurora flickered in the North, cold flames of the same ghastly fire flickered above the graves of the old Norse ancestors.

The Iroquois people were troubled by similar intimations. They imagined the aurora as the entry point into the Land of Souls, where the sky rose and fell to let spirits into the world beyond. For many other northern aboriginal peoples, the lights were seen as the actual spirits of dead ancestors. Sometimes their progress across the sky was interpreted as a torchlight procession or a joyful dance (perhaps inspired by the "cheerful" thought of relatives who would soon die and join them), but more often their erratic movements conjured up alarming images, especially when the lights were tinged a lurid red.

According to a circumpolar tradition shared by Eskimos in Alaska, Inuit in Canada and Greenland, Samis in Scandinavia and Russia, and various Siberian peoples, the northern lights are the souls of those who have died through loss of blood, whether in childbirth, by suicide or through murder. Elevated to the frozen snowfields of the sky, these spirits dash to and fro playing a macabre game of soccer. Sometimes the ball they kick is a human skull; sometimes it is a walrus head. In certain traditions, the head is alive and can be heard chattering its jaws in pleasure or roaring viciously as it slashes at the players with its tusks.

According to the Chukchi people of Siberia, spirits who have hanged themselves are honoured spectators at the auroral game. On the rare occasions when they join in the sport, they play awkwardly because of the ropes that still dangle from their necks. The souls of dead infants can be seen up there, too, trailing their long, gory ribbons of afterbirth.

But to many other observers, the violent play of the lights did not resemble a game of ball, however bizarre. To them it looked like war. Sometimes the heavenly battle

This sketch of the aurora represents the Chukchi conception of the northern lights. The diagonal lines divide the sky into spiritual zones. Spirits are assigned to specific parts of the aurora, depending on how they died. The western quadrant, for example, is reserved for those who were killed by sharp weapons, especially through suicide. From The Chukchee *by W. Bogoras, 1909.*

OPPOSITE: *Chinese scholars looked to the sky for messages from supernatural powers. Auroras were perceived as symbols or diagrams that could provide guidance if rightly interpreted. These Chinese representations of the aurora were published in 1652.* COURTESY OF ROBERT H. EATHER

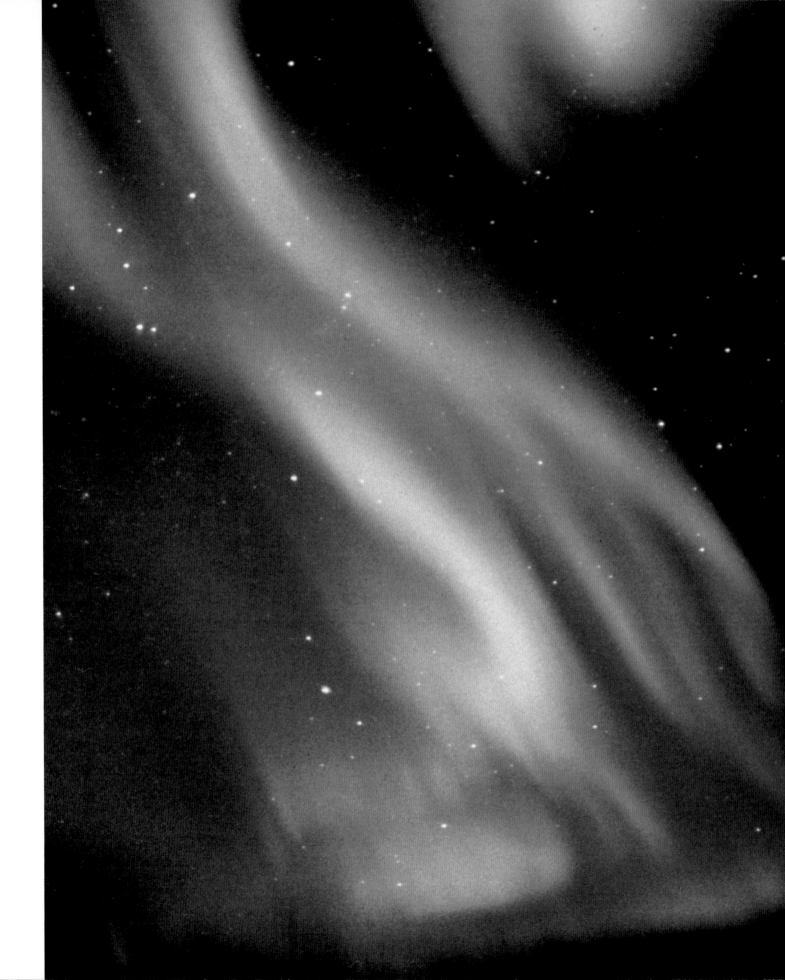

INUIT SPACE FLIGHT

When Neil Armstrong took his first step on the moon, a journalist asked an elderly Inuk what he thought of the historic achievement. A man on the moon? the old man said. There was nothing new about that. Inuit shamans had been visiting the moon for millennia.

For those who made the journey, an ascent to the land of the moon was a profound religious experience. Often the journey began at night, under a full moon, when the shaman was standing at a blowhole, staring into the black swirling water and waiting for a seal to rise. Suddenly, he would notice a sled descending out of the sky. It would land nearby, and the shaman would climb on board. Once he reached the land of the moon, he might meet dead relatives or watch spirits playing ball in the northern lights.

Sometimes the spirit journey took place during a ritual performance in which the shaman was bound hand and foot on the floor of a hut, surrounded by members of his community. When the lamps were blown out, the shaman could be heard leaving through the roof and, a little later, coming in again. Yet when the lights were lit, he lay on the floor with the ropes still in place. When everyone had recovered from their amazement, the shaman would tell where he had been and what he had learned.

As recently as 1990, Suzanne Niviattian Aqatsiaq of Igloolik, in northern Canada, remembered how her grandfather used to visit the northern lights to see his wife, who had died from loss of blood during childbirth.

OPPOSITE: *Like a shining pathway of light, the aurora led spirit travellers into the night sky. This is a display of the southern lights.* WORLD DATA CENTER C2 FOR AURORA, TOKYO

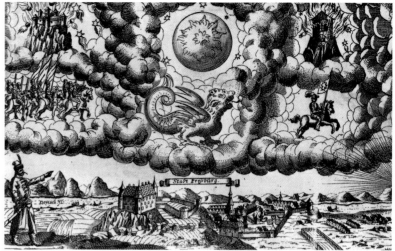

Ein vnerhörtes Wunderzeichen/ welches ist gesehen worden

auff Kuttenberg in der Kron Böhem/ auch sonst in andern Stätten vnd Flecken herumb/
den 12. Januarij/ vier stund in die Nacht/ vnd geweret biß nach 8. Inn der Wolcken
des Himels stehen/ alß in diesem Jar. 1570.

Von einem erschröcklichen Wunderzeichen/ welches sich in

diesem 1605. Jahr/ den 7. Novembris/ zu abend vmb 6. vhrn/ vnnd folgends die gantze Nacht über/
am Himmel hat sehen lassen/ da sich der Himmel Blut vnd Fewerroth/ mit schönen weissen hin vnd wider
schiessenden Strahlen erzeigt hat.

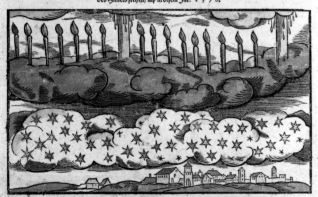

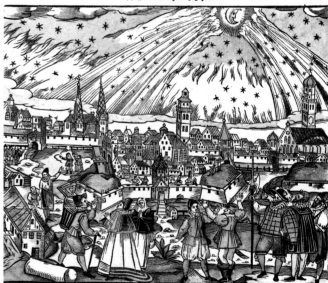

IM Jar 1570. den 12. Januarij vier stund in die Nacht/ ist diß Wunderzeichen erschienen am Himel zwischen Mitternacht vnd dem Auffgang in solcher gestalt.

Getruckt zu Augspurg/ bey Michael Manger.

was bloodless and abstract, as in the Finnish belief that the Archangel Michael stood arrayed in light to fight with Beelzebub. In that case the aurora was understood to be a fiery warning to resist one's own sinfulness. But usually the conflict was pictured as a literal combat among the souls of those who had died through violence, especially warriors who continued fighting after death. The Samis sometimes referred to the lights as *runtis-jammij* ("some who are killed by the use of iron") and described them as quarrelsome spirits that lived together in a large hall. When a brawl broke out among them, they stabbed each other to death, and the floor of their quarters was stained blood red. If blood from an auroral battle rained down over the Hebrides, it might congeal into the coloured pebbles that are known as blood stones or fairy blood. As recently as 1871, an auroral observer in London declared that he had heard the distant clash of weapons when the lights raged overhead.

Bad enough that the very heavens should be aflame with battle; worse yet to know that this sign foretold calamity on earth—death, pestilence, assassination, political upheaval and armed combat. Not surprisingly, this portent was most troubling for people who lived outside the auroral zone, where strange lights in the night sky were a rare and terrible occurrence. (As it happens, the great auroras that appear at low latitudes are also more likely to be red, which gives them an even more threatening appearance.) Thus the Roman author Pliny the Elder declared in 112 B.C. that "there is no presage of woe more calamitous to the human race" than "a flame in the sky," or a display of northern lights.

Who could doubt it then or since? In 507 A.D. the citizens of Rome awoke to the sight of glowing armies in the sky and the sounds of ghostly trumpets, just as their empire crumbled under an attack by the Longobards. Several hundred years later, Henry of Huntingdon saw the skies of Northumberland, England, aflame with light and sparks and took it as a sign of terrible bloodshed and conflagrations to follow—predictions that were tragically confirmed during an ill-fated rebellion in 1138.

By the late Middle Ages, a brilliant display of aurora caused total, pathetic panic among Europeans. People fainted and went mad at the sight. Even in the sixteenth century, country people were so alarmed by these signs of divine displeasure that they poured out of their villages to make penance at major cathedrals. Thus, as auroral scholar Alfred Angot reports,

OPPOSITE: *When the northern lights appeared over western Europe in the 1500s and 1600s, people ran into the streets to witness the strange and terrible apparitions. Pamphlets were prepared to broadcast the celestial warnings.*

TOP LEFT: STAATSBIBLIOTHEK BAMBERG; TOP RIGHT: MAGYAR NEMZETI MUZEUM, BUDAPEST; BOTTOM LEFT AND RIGHT: GERMANISCHES NATIONALMUSEUM, NÜRNBERG

in the month of September 1583 eight or nine hundred persons of all ages and both sexes, with their lords, came to Paris in procession, dressed like penitents or pilgrims . . . "to say their prayers and make their offerings in the great church at Paris; and they said that they were moved to this penitential journey because of signs seen in heaven and fires in the air, even towards the quarter of the Ardennes, whence had come the first such penitents, to the number of ten or twelve thousand, to Our Lady of Rheims and to Liesse." The chronicler adds that this pilgrimage was followed a few days afterwards by five others, and for the same cause.

More than three centuries later, on 13 October 1917, Our Lady of the Rosary, Mother of God, appeared miraculously to three children in Fatima, Portugal, and warned of "a night illuminated by an unknown light" when a "terrible war will begin." And, just as prophesied, on 25 January 1938, the heavens over western Europe were "filled with a strange and terrible crimson fire" that, to some, presaged the Nazi invasion of Austria three months afterwards. Four years later, violent displays of aurora flared over the United States for three nights straight, as far south as Cleveland, Ohio— an awful portent, it was later said, of the Japanese assault on Pearl Harbor.

By treating the lights with holy dread, people have traditionally attempted to keep their evil influence at a distance. The auroral spirits can be spiteful and easily irritated. A folktale from Norway tells of a boy who dared to chant at them—

The northern light is running lip, lip, lip
with fat in its mouth lip, lip, lip
with a hammer in its skull lip, lip, lip
with an axe on its back lip, lip, lip—

whereupon the lights zoomed down and burned him to a crisp.

Although some traditions suggest the aurora can be placated by singing, most northern peoples agree that whistling and singing at the lights are highly risky. The lights get aroused when they hear these sounds and think they are being teased. At the very least, they run faster and writhe into new forms; at worst, they take offense and come plunging down. People are said to have been blinded, paralyzed and decapitated by these assaults; others have been abducted into the lights' cold brilliance. In French

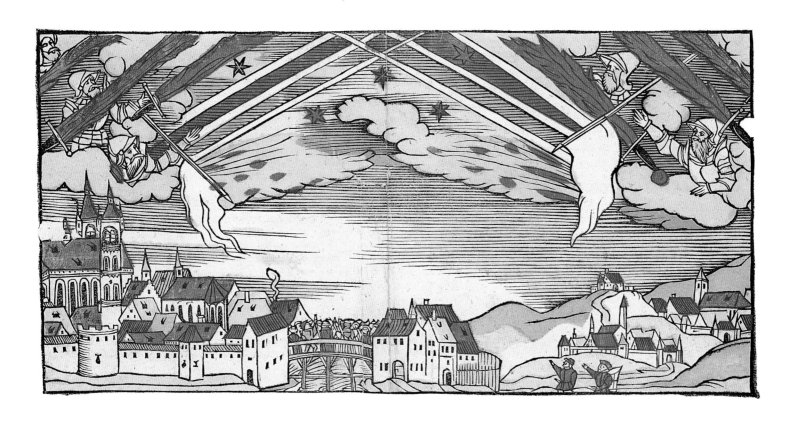

In 1560 an aurora over Bamberg, Germany, presented the frightening spectacle of clashing armies clad in shining armour and brandishing bright swords. DEPARTMENT OF PRINTS AND DRAWINGS OF THE ZENTRALBIBLIOTHEK ZÜRICH

ABDUCTED BY ALIEN POWERS

Catherine Mitchell is a Gwich'in woman who grew up in and around the Mackenzie Delta in Canada's Northwest Territories. When she was a child, her mother used to warn her about the aurora. The lights were not what they seemed to be, her mother said; they were not to be trusted.

It seems there were once two foolish children, a Loucheux girl and a boy, who ignored this caution. They were sewing a skin bag and wanted to gather some stars to decorate it. So they went out together into the night and whistled and called to the lights. Right away the brightness swooped to the ground and carried them up to the sky. There they met two men, the only people who lived and hunted in the upper world.

A day passed, a month, a year, and soon the children realized that they were trapped. How could they get home? In secrecy, the children fashioned a rope of skins, which they hid from their captors. When the rope was finally long enough to reach the ground, the two children slid all the way down and gratefully returned to their people.

"My mom always said it's real dangerous to fool around with northern lights," Catherine says. "What happened to those kids will happen to you if you disturb them."

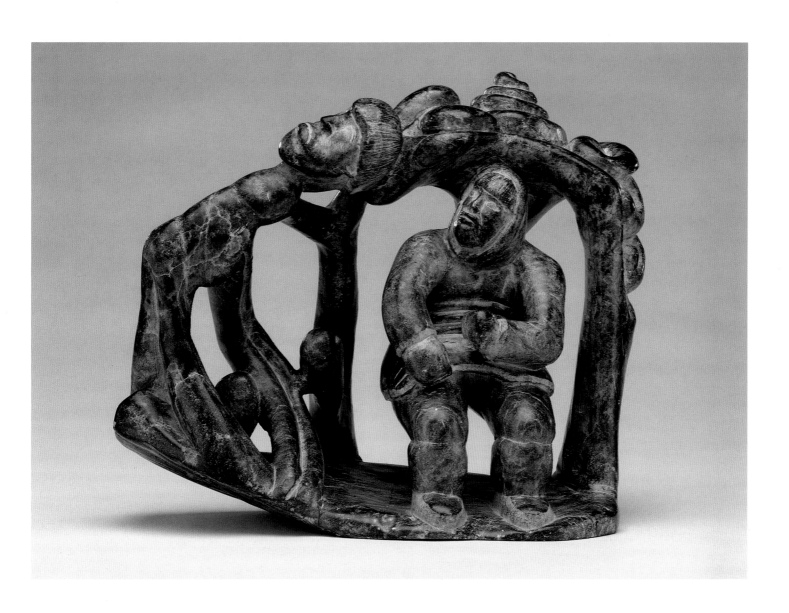

"The Aurora Borealis Decapitating a Young Man," a soapstone sculpture by Inuit artist *Davidialuk Alasua Amittu.*

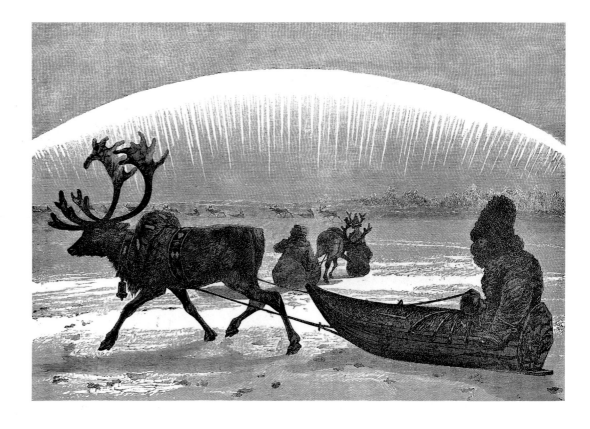

The tinkling bell at the neck of this reindeer is intended to keep the ominous influence of the lights at a safe distance.
COURTESY OF ROBERT H. EATHER

OPPOSITE: *The beauty of the aurora delights us, but its mysterious power inspires an age-old awe. This intense corona was photographed in northern Canada.* NORBERT ROSING

Canada, a fiddler who charmed the lights with his music was seized by the rays and bewitched.

"When the Aurora Borealis falls," warns a Gwich'in text, "when it runs close to man, the human brain goes mad and man is seized by the Heart and killed. That is why we are frightened of it and why we reject it utterly and have done for a long time."

To people who lived in the spirit-filled world of traditional cultures, one fact was clear. The forces that dance in the polar dark are awe-inspiring—alien, uncontrollable and immensely vigorous. With that conclusion, at least, modern science would have no argument.

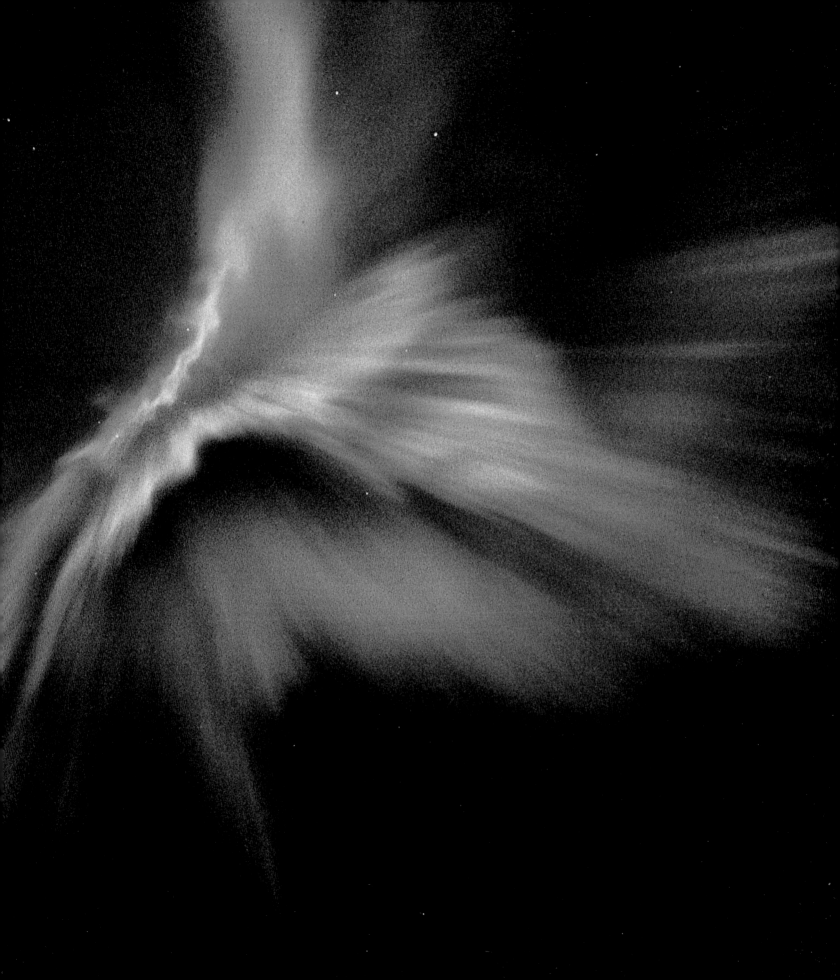

uno prælio nunquam amplius priftinam recuperarunt potenti
am .Cafparus Beucerus de Meteorologia fol.25 3.

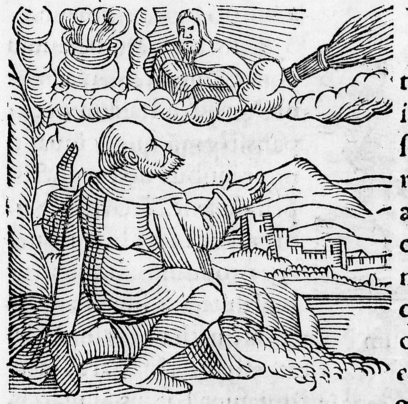

Vidit Ieremias propheta
in coeli nubibus ingen
tem uirgã, atcp ad cædẽdum
iam paratã: ollã pterea fuccẽ
fam, & faciẽ eius (ut fcriptu
rǫ facrǫ uerbis utar) à facie
aquilonis: et audiuit dñm di
centẽ: Vigilabo fuper uerbo
meo, ut faciam illud, & ab a
quilone pãdetur malũ fuper
oẽs habitatores terræ , quia
ecce ego conuocabo oẽs co
gitationes regnorũ aquilo
nis, & uenient, ponentcp unufquifcp folium fuum in introitu por
tarũm Hierufalẽ. Reliqua uide apud Ieremiam cap.1.

On the fifth day of the fourth month of 593 B.C., the prophet Ezekiel stood on the bank of the river Chebar in what is now southern Iraq and "saw visions of God." From the details of his description, many interpreters believe this epiphany was inspired by a rare and magnificent outburst of aurora.

As I looked, behold, a stormy wind came out of the north, and a great cloud, with brightness round about it, and fire flashing forth continually, and in the midst of the fire, as it were gleaming bronze. And from the midst of it came the likeness of four living creatures. . . . And each went straight forward; wherever the spirit would go, they went. . . . In the midst of the living creatures there was something that looked

CHAPTER 3 LUMINE BOREALI

like burning coals of fire, like torches moving to and fro among the living creatures; and the fire was bright, and out of the fire went forth lightning. And the living creatures darted to and fro, like a flash of lightning. . . . Over the heads of the living creatures there was the likeness of a firmament, shining like crystal. . . . And above the firmament over their heads there was the likeness of a throne, in appearance like sapphire; and seated above the likeness of a throne was a likeness as it were of a human form. . . . Such was the appearance of the likeness of the glory of the LORD. And when I saw it, I fell upon my face, and I heard the voice of one speaking.

At the very moment when Ezekiel prostrated himself before this awesome presence, a philosopher named Anaximenes may have been enjoying the same splendour over Miletus, a Greek city on what is now the Turkish coast. But where the prophet saw and heard the Lord God, the philosopher perceived only "inflammable exhalations from the earth." To put it in modern terms, Anaximenes interpreted the aurora as a cloud of burning gas.

There is no easy way to bridge the differences between these two experiences and explanations—Ezekiel's passionate, hallucinatory encounter with Spirit; Anaximenes'

OPPOSITE: *A woodcut from Lycosthenes'* Prodigiorum, *published in 1557, shows the prophet Jeremiah receiving visions from the Lord. "What do you see?" the divine voice asks. "I see a boiling pot," Jeremiah replies, "facing away from the north." Some interpreters think Jeremiah's vision was inspired by an aurora.* HOUGHTON LIBRARY, HARVARD UNIVERSITY

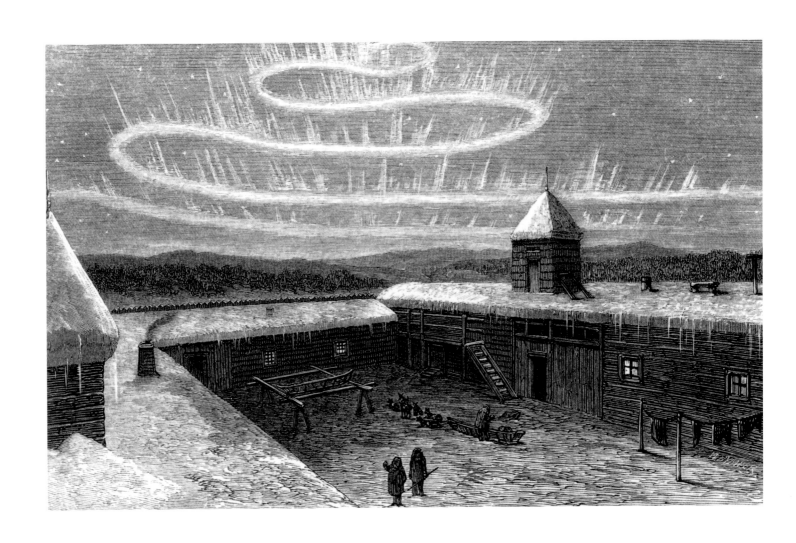

dry invocation of matter. For Ezekiel, the fundamental reality that manifested itself in the aurora and other phenomena was divine and living. But Anaximenes was a pioneer in the revolutionary new mode of human understanding that came to be known as natural philosophy, and for him, fundamental reality was material and mechanical. This is the viewpoint that we have inherited as "scientific."

Anaximenes believed that everything in the universe derives from a single source, which he said was air. From that starting point, he developed a theory that might best be described as the apotheosis of evaporation. Having somehow determined that invisible air gives rise to visible clouds, he deduced that, at greater densities, air condensed in the form of soil and stone. At the other end of the scale, at very low densities, air was transformed into fire. Thus, air rising from the earth would become rarefied and burn in the heights, where it was perceived as the aurora and other heavenly lights.

In the next century, Hippocrates of Chios and his student Aeschylus proposed that the auroral vapours were not themselves on fire but were lit by stray sunlight. According to their model, the sun slid under the earth at night. What would prevent a few errant rays from slipping out, past the edge of the planet, beaming onto the clouds of vapours and making them shimmer?

A more radical notion was put forward at about the same time by a freethinker named Anaxagoras, who said the earth was bathed in fiery vapours that poured down from the sky. These vapours accumulated in the clouds until they burst into flames, giving rise to lightning, comets and aurora, under varying conditions. It is hard to say if anyone took his ideas seriously, for he was widely condemned for his bizarre beliefs, including the assertion that the sun was a large ball of fire (even bigger, he claimed, than the Peloponnese). For this impiety, he was forced out of Athens in disgrace about 450 B.C.

When Aristotle approached the subject of the northern lights a century later, he prudently gave a wide berth to Anaxagoras's prophetic heresies. In Aristotle's cosmology, any interaction between heaven and earth was an outrageous impossibility. He took it as a basic truth that the heavens were perfect and unchanging—a belief characterized by Carl Sagan as "the most influential error in the history of astronomy, contributing to a detour from reality" that lasted for more than nineteen centuries. But whatever Aristotle may have lacked in vision, he compensated for with confident certainty. "In the whole range of time past," he averred, "so far as our inherited records reach, no

OPPOSITE: *Historically, the way the aurora was represented depended on how it was understood. In this illustration from* Travel and Adventure in the Territory of Alaska *by Frederick Whymper, 1868, the lights resemble a banner of ice crystals.* COURTESY OF SPECIAL COLLECTIONS, UNIVERSITY OF SASKATCHEWAN

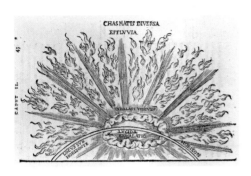

When Gemma's De Naturae Divinis Characterismis *was published in 1575, it included this depiction of the aurora. Based on Aristotle's theory, the drawing shows exhalations of fiery vapours that form various kinds of* chasmatis, *or auroral chasms.* HOUGHTON LIBRARY, HARVARD UNIVERSITY

change appears to have taken place either in the whole scheme of the outermost heaven or in any of its proper parts." Only in the "sublunar" zone near earth could anything move or change, and so that is where Aristotle located the cause of the zestful auroral curtains.

He presented his theory in a book called *Meteorologica*, a work in which he modestly accounted for all the changeable phenomena beneath the heavens. Earthquakes, typhoons, thunder and hoar-frost all fell before his unflappable assertions. So, in turn, did various lights in the sky, including what we would call comets, meteorites and the aurora, but which Aristotle muddled together as "shooting stars," "torches," "chasms," "trenches," "blood-red colours" and, improbably, "goats." All of these, he affirmed, were "the same thing and due to the same cause." Without so much as a nod of acknowledgement to Anaximenes three centuries earlier (whose views he elsewhere characterized as "foolish and lisping"), he explained that the earth produces "exhalations" that separate into layers depending on their density, with earth and water at the centre, followed by a band of air and, finally, a zone of a smoky vapours known as elemental fire. This uppermost layer of flammable fumes is on the farthest edge of the sublunary realm and actually touches the heavens. Because the celestial spheres slowly rotate, they cause the elemental fire to circulate and burst into flames. Thus the lights are produced.

In his book *Coming of Age in the Milky Way*, Timothy Ferris offers a one-sentence summary of Aristotle's influence. His mind was "a killing jar," Ferris says; "everything that he touched he both illuminated and anesthetized." Under the sedative of Aristotelian self-assurance, the scholars of Greece and, later, of western Europe ceased to speculate about the aurora and most other phenomena. The universe had been described and every problem solved. It was not until 1572 that a distant explosion shattered their confidence. In November of that year, a Danish astronomer and eccentric named Tycho Brahe pointed his metal nose to the sky (he had had it capped with copper to hide duelling scars) and made an observation that changed the universe. He saw a star appear where no star had been before, a nova in the constellation of Cassiopeia. Five years later, he observed a spectacular comet and calculated its position far beyond the moon. Something new could appear in the heavens. Aristotle was wrong.

By eliminating the barrier between earth and heaven, Tycho revolutionized Western astronomy and made it possible for the modern explanation of the aurora to

AURORA AND THE WEATHER

Aristotle classified the aurora as "meteorologica," which is to say, as weather. In this he perpetuated an association that has deep roots in folk cultures. People seem always to have assumed that the aurora was an aspect of weather or, at least, a weather sign that could be interpreted. Every community had its own quirky traditions about how the lights could be read. Thus, a brilliant aurora might be said to indicate cold weather or warm weather, north winds or south winds, snowstorms or windstorms. But even if people couldn't agree on what the aurora foretold, everyone took for granted that it foretold something.

In the centuries since Aristotle, scientists have also commonly assumed a weather connection. In the early years of our own century, for example, the great minds of auroral physics were totally convinced that the lights were somehow related to cirrus clouds. In fact, they are not. Nor are they associated with any of the other factors (humidity, air pressure) that bring about changes in our day-to-day weather.

At the same time, there is growing evidence of a more roundabout influence. As will become clear in subsequent chapters, the sun experiences long-term changes that affect the aurora. It now seems likely that these solar processes also have an impact on long-term climate patterns. Dramatic evidence of this connection has been provided, in retrospect, by the Maunder Minimum, which lasted from 1645 to 1715. During this seventy-year period, very few auroras were observed over central and southern Europe. Coincidentally, the continent experienced a cold spell so severe that it has become known as the Little Ice Age. No one can say for sure why these changes occurred, but it seems likely that a mysterious slowdown in the sun affected both the aurora and the earth's temperature.

The Maunder Minimum is an unexplained exception to the sun's usual behaviour. Ordinarily, solar activity follows a regular eleven-year pattern, which is mirrored in the eleven-year cycle of the aurora. Recent research suggests that this solar cycle may also correlate to changes in global wind patterns. Given the complexity of the sun-earth system, it may be many decades before such large-scale relationships can be confirmed.

THREE MEDIÆVAL THEORIES

During Aristotle's long intellectual reign, few original voices made themselves heard on scientific matters. One exception was an unknown Viking scholar who, in 1250 A.D., prepared a chronicle entitled *The King's Mirror*. In it, he presented three contemporary theories about the aurora. The first suggested that the lights "shine forth from the fires that encircle the outer oceans" of the globe. The second (unconsciously echoing the ideas of Hippocrates) posited stray gleams of sunlight that slipped past the curve of the earth and beamed into the night sky.

"But there are still others who believe (and it seems to me not unlikely)," this author confessed, that the intense cold of arctic "frost" and "glaciers" are themselves the source of the aurora's radiance. "I know nothing further that has been conjectured on this subject, only these three theories that I have presented; as to their correctness I do not decide," he wisely concluded.

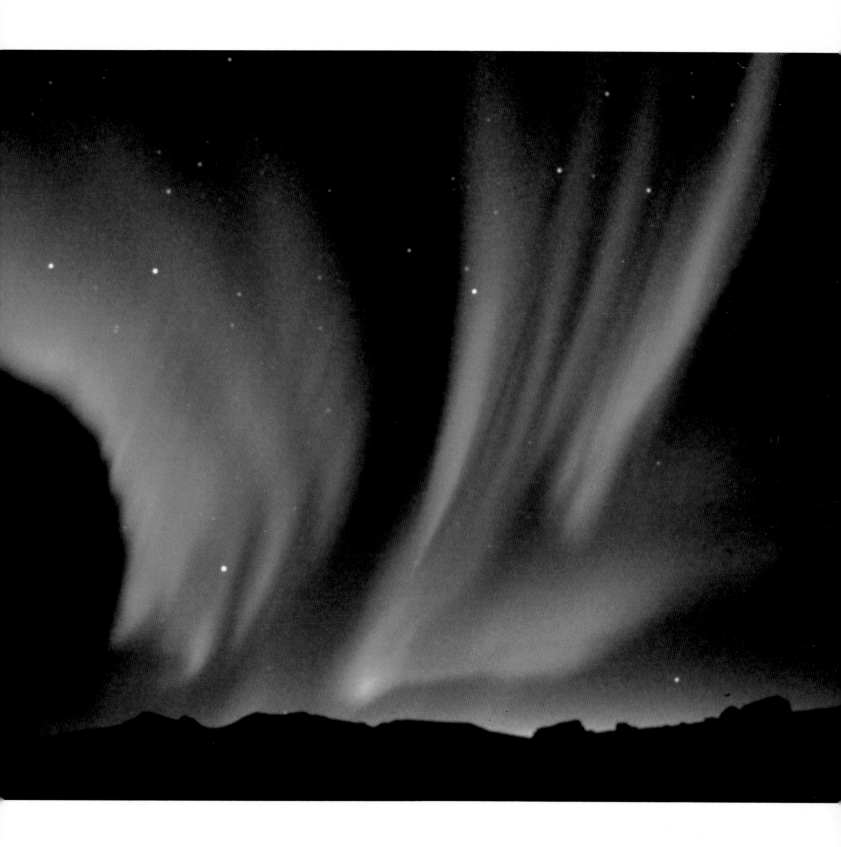

emerge. But in many ways, his scientific views were surprisingly stodgy. For one thing, he shared Aristotle's notion that the northern lights were caused by vapours from the earth, adding only that these fumes were likely sulphurous. For another, he could not bring himself to endorse the theories of Copernicus, whose description of a sun-centred planetary system seemed to him an affront to common sense. Accordingly, Tycho developed a complex version of an earth-centred universe—a system that he used very ingeniously to explain the movements of several comets.

Tycho's success at this task made him a great favourite of churchmen and conservative scholars, who hailed his work as a refutation of Copernicus's threatening theory. But his accomplishment did not endear him universally. In particular, it earned him the scorn of one Galileo Galilei who, by the early 1600s, was under caution from the church for his Copernican writings. Aging, ill and circumscribed by the thought police, Galileo had lapsed into an uneasy silence, until word reached him about a pamphlet "On the Three Comets of 1618" that promoted Tycho's regressive thinking.

Galileo found himself in an intellectual bind. Although he was sure that Tycho was wrong, he could not prove that Copernicus was correct. More specifically, he did not know how to plot the course of comets through a sun-centred universe.

There was only one option, and Galileo took it. He set out to prove the old Aristotelian thesis that comets are actually lights that shine below the heavens, in the atmosphere. This he did by likening comets to the northern lights. He explained the latter conventionally as "vapour-laden air" that "being extraordinarily sublimated has risen above the cone of the earth's shadow so that its upper parts are struck by the sun and made able to reflect its splendor to us." This formed what Galileo for the first time described as a "northern dawn," or *boreale aurora*, a poetic likeness that was picked up by later authors and eventually gave rise to our term aurora borealis.

But if terminology was progressing, the same could not be said for explanations of the phenomenon, which had been lost in a fog of earthly fumes for some twenty-two centuries. In 1638, when René Descartes published his book on *Les Météores*, he trotted out idiosyncratic variants of the same old tired themes. In an explicit attempt to find a plain-jane mechanistic cause for every natural wonder—"in such a way that one will no longer have occasion to marvel at anything he sees"—he suggested that the aurora was made up of clouds. Noting that the displays sometimes inspired ignorant people "to imagine squadrons of ghosts that fight in the air and through which they

THE MYSTERY OF AURORAL SOUND

Just as people have seen the lights in different guises, so they have heard them make different sounds. The Inuit, for example, sometimes heard the swish and crackle of feet on the heavenly soccer grounds. The French, in Descartes's day, were more likely to hear "small noises" from a celestial battle.

It is hard to know what to make of these traditions. Nowadays, at least, most auroras do not make any sound. As Alexander von Humboldt noted dryly in 1847, "Northern lights appear to have become less noisy since their occurrences have been more accurately recorded." But at the same time, the lights have not been entirely silenced. As recently as 1973, the journal *Advances in Physics* published an article on "auroral audibility" that reported on 198 cases of auroral sounds, mostly from the nineteenth and twentieth centuries. Many came from highly credible observers, including auroral researchers, in various parts of Canada, the United States and Europe. These accounts strongly suggest that auroral sound—a faint, crackling hiss that follows the ebb and flow of fast-moving curtains—is a rare but real phenomenon.

There is only one problem with this assertion. The aurora would not logically be expected to make a sound. Descartes's theories notwithstanding, the lights are not associated with any movements or vibrations that we would expect to hear. And even if sound waves were somehow created, it would take them about five minutes to travel from the lights to the ground (a distance of at least 80 to 100 kilometres). Yet the sounds are said to occur at the same time as brilliant auroral outbursts.

So what could be going on? Scientists have come up with several ingenious theories. For example, it is known that radio waves are produced in the upper atmosphere during auroras. If these waves were propagated towards earth, they might set up vibrations in piezo-electric materials within the soil and rocks. These are naturally occurring crystals that expand or contract when they are subjected to electromagnetic radiation. People with sensitive hearing might pick up these vibrations as rustling sounds.

Another possibility is that the aurora causes static electricity to build up in the atmosphere, and that this is responsible for the crackle and hiss. It may even be that this "sound" is not created as waves in the atmosphere but as a direct sensation inside the ear. If this is the case, it would account for another mysterious characteristic of auroral sound. It has never yet been picked up by a tape recorder.

can foretell the defeat or the victory of the side that they support," he hypothesized "smallish clouds capable of being taken for as many soldiers, and which, falling one upon the other, envelop enough exhalations to cause a quantity of little lightning bolts and to throw little fires, and perhaps to cause to be heard small noises as if these soldiers were in combat." Failing that, he speculated that the light was reflected from distant storms or from the sun.

This venerable theory—that the aurora occurs when clouds or vapours high above earth are struck by sunlight—was "proven" experimentally in the 1740s by a bewigged Swedish man of letters named Samuel von Triewald. In what may have been the most sweetly aromatic setup in scientific history, von Triewald passed a beam of light through a prism, over a glass of cognac and onto a screen. As the vapours arose from the cognac,

> one was surprised to see a naturally occurring northern light on the screen that nothing could more resemble. As the cognac surface was warmed up by the coloured Sun rays it began to evaporate, and with that comes into existence a wonderful movement on the screen. . . in which man sees all the phenomena like any natural northern light produces. . . . Never be man tired regardless of how long he looks at this experiment, for in addition it is by far the most beautiful one can produce in a dark room.

Also the most delicious to clean up when the experiment is complete.

Meanwhile, back in the real world, science was moving along, most notably with the publication of Isaac Newton's *Mathematical Principles of Natural Philosophy* in 1687. Again it seemed that all the perplexities of the universe had been laid to rest. Or so thought Newton's friend and editor, Edmond Halley, whose ability to predict the return of a large comet provided the first definitive proof of Newton's system. But Newton's triumphant mathematics had failed to dispel at least one mystery, a fact that came dramatically to Halley's attention on 6 March 1716. That evening his visit at a friend's house in London was interrupted by word of a "strange sort of Light" in the heavens. "We immediately ran to the Windows" and beheld "a most agreeable and wish'd for Spectacle"—a magnificent aurora. Halley had had the misfortune to be born during a period called the Maunder Minimum, when auroral displays were extremely rare, so this was his first chance to contemplate them, as he put it, "*propriis oculis.*" Of

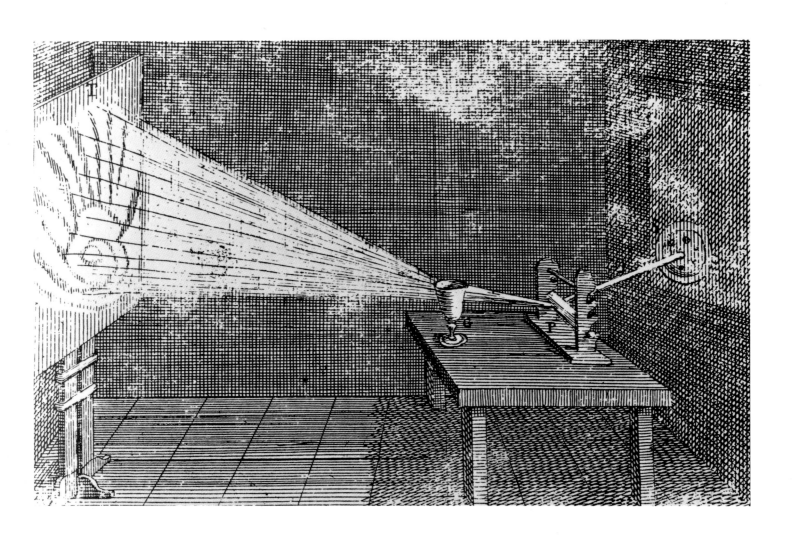

These scientific drawings of the northern lights were published in Copenhagen in 1745. Figures 1 through 4 illustrate relatively quiet displays that were observed in 1707 and 1710. Figure 9, by contrast, represents the pyrotechnics that filled the skies in March 1716. COURTESY OF ROBERT H. EATHER

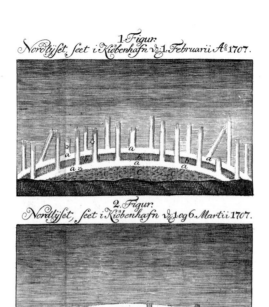

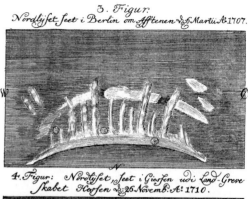

9 Figur.

Nordlyset set i Dantzig d. 17. Martii Anno 1716.

"all the several Sorts of Meteors I remember to have hitherto heard or read of," he wrote, "[t]his was the only one I had not as yet seen, and of which I began to despair."

Despite his inexperience as an auroral observer, Halley knew at once what he was *not* seeing:

> By this particular we were first assured, that the Vapour we saw, whatever it were, became conspicuous by its own proper Light, without help of the Suns Beams: for these *Nebeculae* did not discover themselves in any other part of their passage. . . [except] where being opposite to the Sun they were deepest immerst in the Cone of the Earths Shadow; nor were they visible before or after. Whereas the contrary must have happened, had they borrowed their Light from the Sun.

Nor could he persuade himself that they derived from any "ordinary Vapours or Exhalations of the Earth or Waters," partly because (as he soon ascertained) the lights were seen at about the same time all over northern Europe. "Nor can we this Way account for that remarkable Particular attending these Lights, of being always seen on the Northside of the Horizon, and never to the South." Therefore, he concluded, "we are forced to have recourse to other sort of *Effluvia* of a much more subtile Nature, and which perhaps may seem more adapted to bring about those wonderful and surprisingly quick Motions we have seen."

Twenty-five years earlier, Halley had speculated about just such a subtle effluvium in a scientific paper on magnetic declination. Declination is the difference between "true," or geographic, north and the north of the compass. Not only does this angle vary from place to place, but it also changes in any one place from year to year. In an attempt to explain this phenomenon, Halley postulated that the earth might be a hollow shell, with one or more smaller globes nested within it. If all these concentric spheres were magnetic and the inner globes free to move, then their changing positions relative to one another might account for the changing direction of the compass heading.

And that was just the beginning of the great man's theory. Halley went on to inquire "of what use these included Globes can be." Noting that "all parts of Creation abound with Animate Beings," Halley boldly took the next logical step. Wasn't it likely that the space between the inner globes was also inhabited? Then, since "without Light there can be no living," there must surely be "some luminous Medium between

the Balls, so as to make a perpetual Day below." And "what should hinder but we may be allowed to suppose" that this lucid matter might sometimes break through the outer shell of the earth and spurt into the sky, to flare across the darkness as the northern lights?

Even Halley recognized that his hypothesis might seem extravagant. "I desire to lay no more stress upon this Conceit than it will bear," he said. But his alternative theories on the aurora were scarcely more ordinary. What if, he wondered, the mysterious lights were not an indirect but a *direct* result of the earth's magnetism. Working on the assumption that atoms of magnetic matter circulate between the poles of a magnet, Halley speculated that "the same sort of Circulation of such an exceeding fine Matter" might be "perpetually performed in the Earth." After all, as his countryman William Gilbert had correctly deduced a hundred years before, the earth is itself "no other than one great Magnet":

> To this we beg leave to suppose [Halley went on], that this subtile Matter, no other-ways discovering it self but by its Effects on the Magnetick Needle, wholly imperceptible and at other times invisible, may now and then, by the Concourse of several Causes very rarely coincident, and to us as yet unknown, be capable of producing a small Degree of Light. . . . This being allowed me, I think we may readily assign a Cause for many of the strange Appearances we have been treating of, and for some of the most difficult to account for otherwise; as why these Lights are rarely seen any where else but in the North. . .

Halley's magnetic theory was little more than an intelligent shot in the dark, but there were soon indications that he might have hit the mark. On 1 March 1741, a Swedish observer named Olof Hiorter saw an aurora and "noted simultaneously a great movement of the magnetic needle." When he mentioned this to his brother-in-law and colleague Anders Celsius (of thermometer fame), Celsius claimed to have noted just such a disturbance but to have kept quiet, in order to see if Hiorter might make the same observation.

Some 6638 hourly readings later, Hiorter concluded that the lights were definitely associated with disturbances in magnetic heading. "But who would have been able to predict that the northern light had a correlation with the magnetic needle?" he asked

aloud. In 1768 another Swede named Johann Carl Wilcke reported that the auroral rays actually "align themselves in the same direction as the magnetic force," a discovery that was confirmed twenty-five years later by the great English chemist John Dalton. The beams of the aurora borealis, Dalton deduced—that "most pleasing and sublime spectacle"—must be "ferruginous in nature, because nothing else is known to be magnetic, and consequently . . . there exists in the higher regions of the atmosphere an elastic fluid partaking of the properties of iron, or rather of magnetic steel."

But not everyone was persuaded by this evidence. Notable amongst the skeptics was a French physicist who gloried in the name of Jean Jacques d'Ortous de Mairan. Though coiffed, powdered and beruffled in the fashion of his day, de Mairan gazes out of his portraits with good-humoured energy. Certainly he approached the mystery of the lights with boyish enthusiasm and an off-the-wall originality. Breaking with two thousand years of tradition, he declared that the cause of the aurora was not to be found in earthly vapours, however exotic. Instead, in unwitting reiteration of Anaxagoras's ancient heresy, de Mairan looked for the answer in the sun. In the three hundred pages of his *Traité physique et historique de l'aurore boréale* of 1733 (the first text on auroral physics), de Mairan likened the aurora to the "zodiacal light"—a faint glow that appears near the horizon after sunset and before sunrise. Both phenomena, he said, are caused by the sun's atmosphere, which he imagined, prophetically, as a rare and tenuous fluid. Although de Mairan was not sure whether this fluid was self-luminous or merely caught light from the sun, he was certain that, in varying amounts, it flowed close to our planet. There it was caught by the earth's rotation and dispersed to the poles, to become visible as the aurora.

De Mairan was enormously proud of his theory and did his best to cover every question that it raised. Why, for example, did the outpourings of the solar atmosphere appear to fluctuate? (In other words, why was the aurora so unpredictable?) Lacking information, de Mairan felt free to speculate. For no very good reason, his thoughts ran to the dark spots on the sun that Galileo, in his first assault on Aristotelian perfection, had seen through his telescope in 1610. "Is it not likely," de Mairan wrote, "that a kind of precipitation of particles from the solar atmosphere causes the spots that so often appear on the surface of the sun? And could not one discover some analogy between the frequency, the cessations and the returns of these spots, and the appearances, returns and cessations of the . . . [aurora]?"

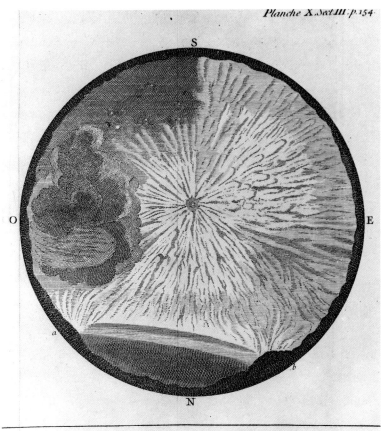

Fig. XVII. Aurore Boreale du 19.me Octobre 1726. telle qu'elle parut dans tout l'Hmisphere Superieur du Ciel, vers les 8. heures du Soir; à Breuillepont, Diocese d'Evreux, 15. ou 16. Lieues à l'Occident de Paris.

Jean Jacques d'Ortous de Mairan published this remarkably accurate depiction of a corona in his treatise on the aurora. He was one of the first to deduce that a corona is an auroral arc viewed from beneath. In the diagrams reproduced below, de Mairan attempted to show how the solar atmosphere might extend towards earth and play a part in causing the aurora. COURTESY OF ROBERT H. EATHER

De Mairan was sure beyond all doubt that he had solved the mystery, and some of his contemporaries enthusiastically endorsed his theory. In the words of one Norwegian physicist, "Mr. Von Mairan's doctrine concerning the northern light will, by future scientists, be considered as wise and trustworthy as the Copernican System concerning the order in which celestial bodies move around each other." But the person from whom de Mairan most wanted approval—Edmond Halley—was chillingly silent. And at least one other prominent scientist openly disputed de Mairan's findings. Leonhard Euler, to whom we are still indebted for our use of the symbol π and many niceties of advanced mathematics, could not bring himself to believe that the atmosphere of the sun came right down to earth. Instead, he put forward another elaborate variant of the sunlight-and-vapours theory. Poor de Mairan was reduced to whimpering: "Notice, if you please, that this is not the only occasion upon which M[onsieur]. E[uler]. has expressly attacked me—I who never pronounced or wrote his name except to sing his praises. I resent both the honour and the consequences of them, and I really wish that he would just leave me in peace."

While poor old de Mairan was coping with these slights, another group of thinkers stepped forward to claim the auroral limelight. Even-handedly contemptuous of all the preceding theories, they believed the aurora to be caused by electricity. Electricity was the glamour science of the late eighteenth century, and it had an international superstar in the person of Benjamin Franklin. Both scientist and statesman, Franklin had, in the words of a French commentator, "snatched the lightning from the skies and the sceptre from tyrants." When he arrived in Paris in 1776 as the representative of the American insurgents, he was given a hero's welcome, and his image was reproduced on snuffboxes, watches, clocks, vases, dishes, handkerchiefs and rings. According to his biographer Carl van Doren, Franklin "was such a fad that Louis XVI, bored with the Comtesse Diane de Polignac's ardours over her American hero, is said to have presented her at New Year's with a *vase de nuit* [chamber pot] of Sèvres porcelain elegantly if surprisingly adorned with Franklin's picture and his Latin epigram."

Franklin's colleagues in the Royal Academy of Sciences greeted him more cordially, and in 1779 he expounded before them on the nature of the aurora borealis. Basically, he suggested that the lights are an electrical discharge phenomenon. For one reason and another, he said, large amounts of electricity are delivered into the polar atmosphere but are prevented from zapping into the earth as lightning because they

Fig. 1

The Arrows represent the general Currents of the Air.
A.B.C. the great Cake of Ice & Snow in the Polar Regions.
D.D.D.D. the Medium Height of the Atmosphere.
The Representation is made only for one Quarter and one
Meridian of the Globe; but is to be understood the same
for all the rest.

Benjamin Franklin produced this diagram to explain how global air currents carried electrical charge to the north and south poles. There, impeded by the "great lake of Ice and Snow," the electricity was forced to flow through the atmosphere and, in the process, became visible as the aurora.

AMERICAN PHILOSOPHICAL SOCIETY

cannot penetrate the ice. Instead, they force their way up through the atmosphere and "run along in the vacuum over the air," moving outwards towards the earth's equator and spreading around its circumference. A slow electrical discharge might then be observed, "strongly visible where densest [near the poles], and becoming less visible as it more diverges [near the equator]. . . .If such an operation of nature were really performed would it not give all the appearance of an *Aurora Borealis*?"

Franklin's electrical hypothesis was seconded in far-off St. Petersburg by Mikhail Vailievich Lomonosov, the first great Russian man of science, who also won a reputation for himself as an historian, literary critic and poet (Pushkin described him as Russia's first university). Although the similarities between his theories and Franklin's invited comment, Lomonosov did not welcome such comparisons: "In my theory of electric force in the air, I do not owe anything to Mr. Franklin. I deduced the cause of it as the result of lowering of the cold upper atmosphere at the start of bitter frosts; that is, from circumstances unknown in Franklin's native Philadelphia."

Whatever its provenance, the electrical theory seemed to be confirmed by laboratory experiments, beginning in the 1750s, with a curious item of apparatus called the "gas discharge tube" (a device that has since been domesticated as the neon light). In the beginning, the discharge tube was simply an enclosed piece of glassware that had been partially emptied of air. When an electrical current was passed through the vacuum, a mysterious light began to glow within the tube—a light that immediately brought to mind the misty auroral ribbons.

But, as always, there were doubters. De Mairan, for one, dismissed the electrical explanation out of hand. "It is astonishing," he scolded, "that in a century in which there is a ceaseless cry against systems, people hurry to build one on a first inspection of a few experiments that have only recently been performed and whose relevance is so remote, so equivocal and, so far, purely speculative."

And so the eighteenth century came to an end, in a stew of conflicting theories. The major ingredients for a correct explanation had been dropped into the pot—earthly vapours and earth magnetism, the solar atmosphere, electricity—but so had handfuls of irrelevant ideas. Given the state of contemporary knowledge and technology, it was literally impossible to distinguish between the breakthroughs and the dead ends. What's more, everyone assumed that only one of the proposed solutions could be correct. For as Newton himself had put it, "It is the perfection of all God's works that they are done with the greatest simplicity." But the dancing lights put the lie to this belief, as they wrote themselves across the sky in a hand both complex and chaotic.

A storm of northern lights sweeps across the horizon.

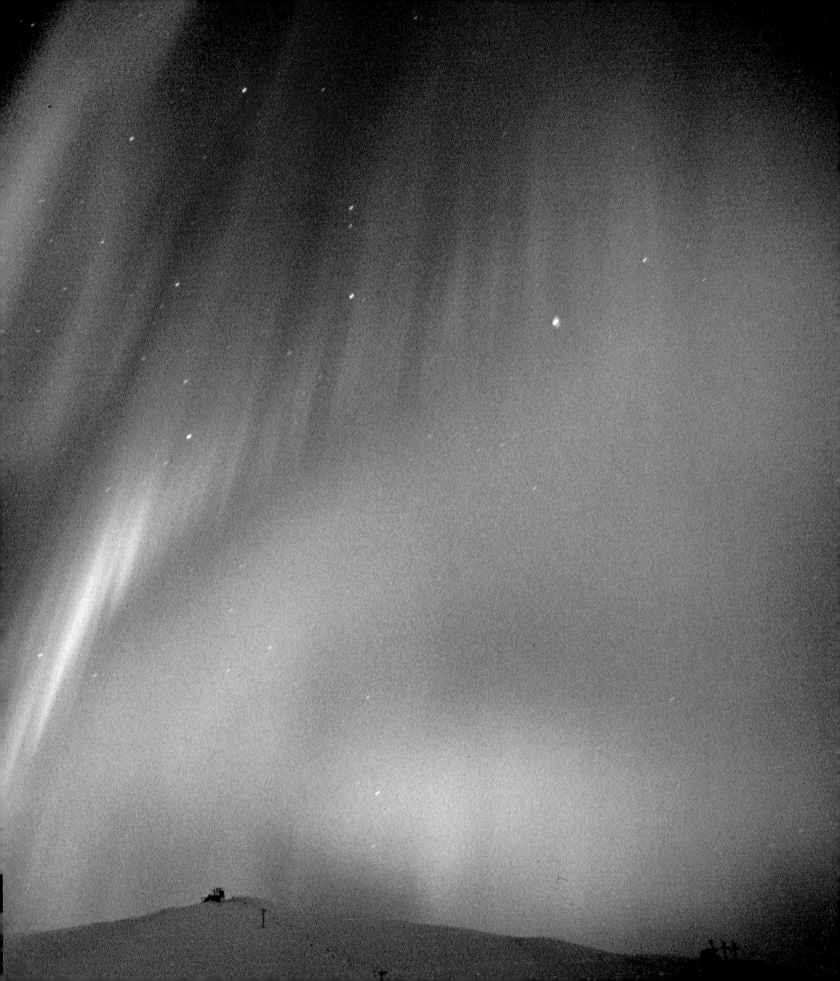

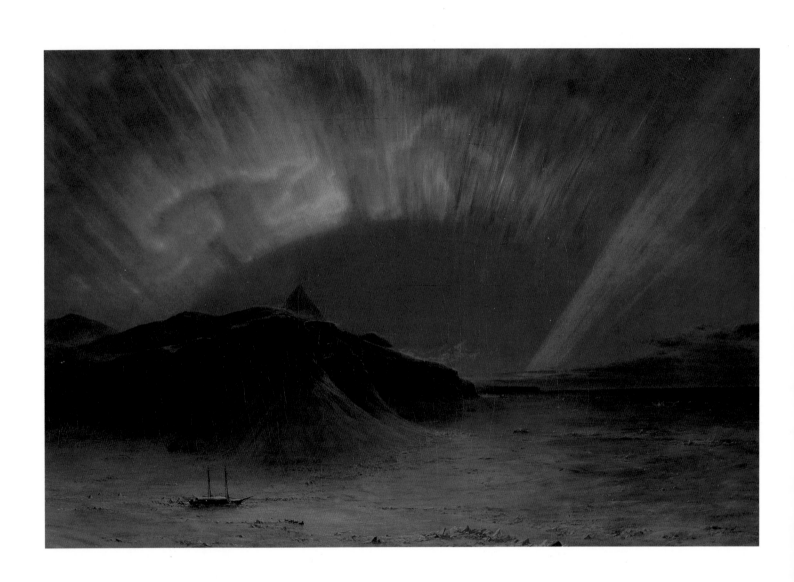

In the seventeenth and eighteenth centuries, auroral theorists enjoyed the advantages of their ignorance. Unencumbered by hard data either to support or refute their speculations, they could debate their ideas for decades, and they happily did. By 1807 one French writer concluded that every possible hypothesis had been advanced to account for the aurora, yet even the strongest of them lacked hard evidence. This uncertainty, he said, "furnishes a new proof, that what we have known longest, is not always that which we know best."

Enter Alexander von Humboldt. Born to a middle-class Prussian family in 1769, Humboldt began his adult life in the government mining service but, freed by a large inheritance, he set out to indulge his passions for travel and science. (Also for scientists:

CHAPTER 4 THE MAGNETIC CRUSADE

two noted French physicists, Louis Gay-Lussac and François Arago, eventually numbered among his love interests.) A late bloomer, Humboldt didn't come to public attention until 1814, when he produced the first volume of his *Personal Narrative*, the story of a five-year research expedition that he made by foot, pack horse and canoe through the mountains and jungles of South America. This three-volume set (together with the thirty-one other books the indefatigable Humboldt ultimately penned to document his trek—"blowing one's own trumpet is part of the job," as he had it) made an explosive impact on educated Europeans. Some years later, one of his admirers acknowledged that his "whole course of life" had been set as a young man by reading and rereading Humboldt's *Personal Narrative*. That admirer was Charles Darwin.

What appealed to Humboldt's fans was not just the epic scope of his travels, which offered the vicarious pleasures of wild rivers, untamed peaks, scented jungles and exotic peoples. They were also drawn to him by the heroic scale of his intellectual ambitions. Humboldt was no mere explorer but a "scientific traveller," whose kit included more than four dozen state-of-the-art instruments for measuring the physical properties of the lands he visited: barometers, thermometers, hygrometers, sextants, telescopes and clocks, together with "a great number of small tools necessary for travellers

OPPOSITE: *A fiery crown of auroral light casts a warm glow across the arctic ice in "Aurora Borealis," an 1865 painting by American artist Frederic Edwin Church. Church's choice of subject matter and his conception of nature were deeply influenced by the writings of Alexander von Humboldt.* NATIONAL MUSEUM OF AMERICAN ART, WASHINGTON, D.C.

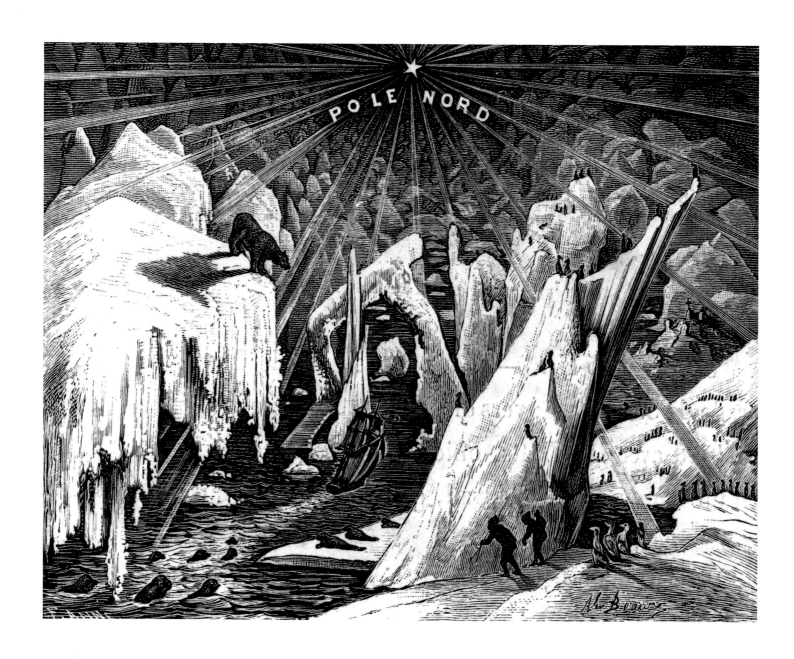

MAGNETIC FIELDS, MAGNETIC LIGHTS

The aurora is the offspring of the earth's magnetic field. If the earth were not magnetic, the aurora would not shine. So solving the enigma of earth magnetism was a step towards developing a science of polar lights.

The mysteries of earth magnetism were first revealed by the strange, inconstant behaviour of the compass. If the earth were a simple bar magnet, then "north" would always be "north." Instead, the north-seeking pole of the compass rarely gives a dead-on reading. What's more, its orientation is far from steady. In London, England, for example, the compass heading has varied by more than forty degrees in the past four centuries. How can this be explained?

Halley had attempted to solve this problem with his concentric globes, but even he acknowledged that his theory was fanciful. For a long time, no one had a more likely mechanism to propose. But we know now that the earth's magnetic force is created mainly by currents of molten rock in the planet's outer core. Because this circulation is turbulent, the magnetic field that it generates—the earth's "main field"—is complex, confusing and somewhat changeable.

But that's not all. Superimposed on these gradual changes are the sudden, sharp disturbances, or magnetic storms, that would soon catch the attention of Alexander von Humboldt (see page 72). As would eventually become apparent, these arise from an entirely different and unexpected source. The difficulty of distinguishing between these two processes caused much perplexity for scientists in the nineteenth century and frustrated their attempts to account for the aurora.

FACING PAGE: *From* Voyage aux mers polaires *by J.-R. Bellot, 1880.* COURTESY OF CANADIAN CIRCUMPOLAR INSTITUTE, UNIVERSITY OF ALBERTA

In 1804 French physicists Louis Gay-Lussac and Jean-Baptiste Biot ascended more than 335 metres in the world's first skylab. Their mission was to study the earth's magnetic field and to sample the upper atmosphere, in the hope of understanding the aurora and other phenomena. (The caged bird was expected to keel over and provide a warning if the air became too thin.)

to repair such instruments as might be deranged from the frequent falls of beasts of burden." Particularly dear to his heart were various devices for collecting data on the earth's magnetic field, widely regarded as the outstanding enigma of the physical sciences. Of all his achievements—setting a height record in mountaineering, identifying 6300 new species, virtually inventing the science of plant ecology—he declared his magnetic discoveries to be the most important result of his American journey.

Certainly they were to him the most fascinating. Home from the Americas by 1805, Humboldt rented a stone cottage on the outskirts of Berlin and set up his magnetic instruments. With a dedication that verged on obsession, Humboldt and an assistant spent the next year hunched over a microscope, recording minute changes in the heading of a magnetic needle. In thirteen months they made thousands of half-hourly readings and recorded not only a regular pattern of daily oscillations but also occasional violent fluctuations, which Humboldt dubbed "magnetic storms." Sometimes, as Celsius and Hiorter had noted half a century before, these inexplicable disturbances were inexplicably accompanied by auroras—"magnetic columns of flame" of such "brilliant beauty" that even the loquacious Humboldt found himself unable to do them justice.

Never one to pose a small answer to a big question, Humboldt began to dream of an international network of magnetic observatories where, through a program of co-ordinated measurements, it would be possible "to distinguish general terrestrial phenomena from those which are mere local disturbances." But the times were out of joint for such a scheme—Europe was at war—and Humboldt was forced to abandon his research for two decades. Finally, in 1828, he recommenced his magnetic readings and began informally to compare results with those of his scientist friends in Paris and Freiburg. The results were startling. The data showed clearly that Humboldt's magnetic storms occurred at exactly the same times in all three localities. Obviously, magnetic "weather" was less local than ordinary meteorological disturbances.

Impassioned by this evidence of a global force at work, Humboldt revived his proposal for co-ordinated study and, in 1829, took the idea with him on a long-anticipated expedition to Siberia. En route, he was given a hero's welcome in St. Petersburg, where he was a frequent guest of the czar and a favourite among the notables of the city. A special session of the Imperial Academies of Science was convened in his honour, and Humboldt used the occasion to advance his agenda. As ever, his enthusiasm was captivating. (Pushkin is said to have likened him to the marble lions in a fountain:

he spouted brilliant talk as they spout water.) Infected with his zeal, the august assembly of Russian scientists agreed to erect a string of magnetic stations from St. Petersburg to Pekin. By 1835 several of them were operating, recording thousands, and then millions, of magnetic readings and auroral sightings.

But Humboldt was not satisfied with collecting masses of measurements. "Observations are not really interesting," he had explained in the *Personal Narrative*, "except when we can dispose their results in such a manner as to lead to general ideas." In later years he reflected that his whole life had been an "earnest endeavor to comprehend the phenomena of physical objects in their general connection, and to represent nature [including the aurora] as one great whole, moved and animated by internal forces [such as magnetism]."

Fortunately for this ambition, Humboldt had taken time before his Russian trip to share his interests with Carl Gauss, an astronomer at the local observatory. A sour, mean-spirited, reclusive man, Gauss made up for his faults with a generous measure of mathematical genius. Aided by a gifted young physicist named Wilhelm Weber, Gauss immediately turned his talents to the challenge of the earth's magnetic field. First he invented improved instruments for measuring magnetic forces; then he established a network of well-equipped and perfectly co-ordinated observatories in Germany, Sweden and Italy, which were linked with those in Russia. Finally, in 1838, he developed a way to calculate the approximate strength of the earth's main field at any point on the globe, thereby making mathematical sense of the rapidly accumulating heap of contradictory and confusing data.

Gauss's elegant formulae were based on a simple assumption—that the earth's magnetic force arose from within the planet. On this basis, he was more or less able to account for the more-or-less stable aspects of the earth's magnetic field. But he was at a loss to explain the sudden "storms" that Humboldt had noted. Still less could he suggest any connection between his earthbound science and the heavenly ethers of the aurora.

Humboldt, as ever, was on the case, instinctively sure that the answers would come with more and better numbers. This meant once again enlarging the research network, a goal that could best be attained by involving the British Empire. In this modest undertaking, Humboldt was seconded by an English artilleryman named Edward Sabine, another enthusiast of geomagnetic research. Himself a scientific traveller of

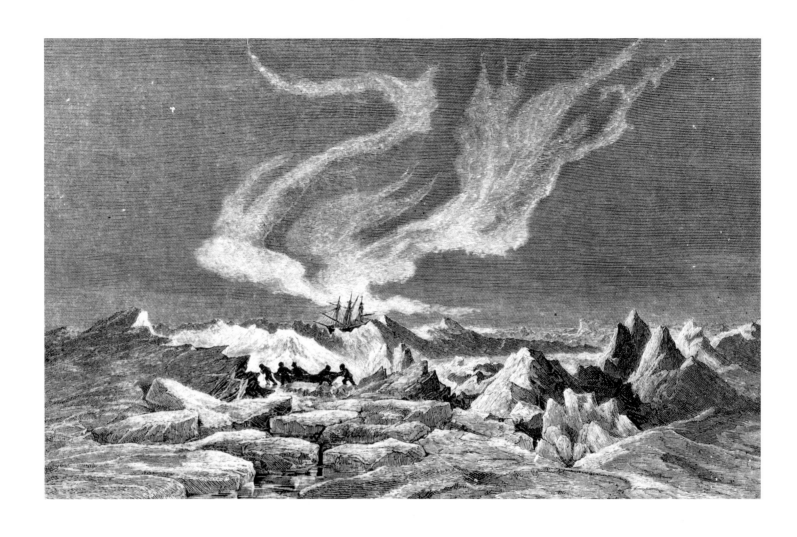

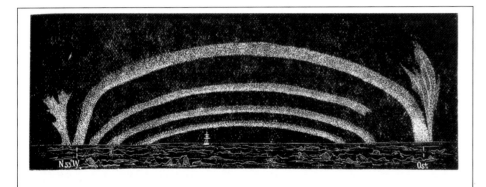

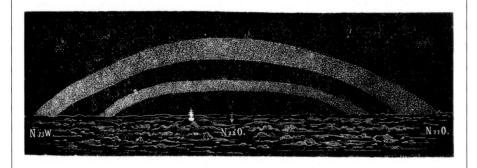

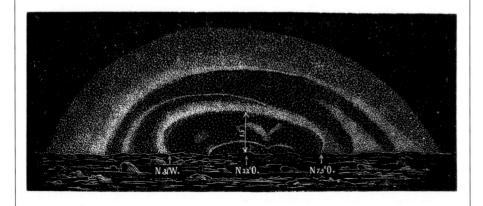

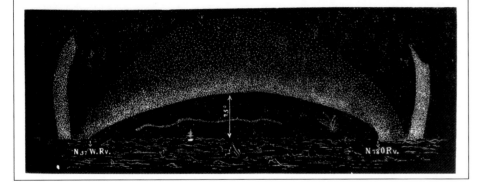

These views of the aurora were recorded from the Swedish vessel Vega, *when it was frozen into the Bering Strait in the winter of 1878–79. From* The Voyage of the Vega round Asia and Europe *by A. E. Nordenskiold, 1883.* COURTESY OF SPECIAL COLLECTIONS, UNIVERSITY OF SASKATCHEWAN

OPPOSITE: *The Austrian ship* Tegetthoff *spent two years bound in the pack ice at latitude 80° north, near Franz Josef Land. In constant peril, the crew nonetheless pursued studies of the aurora and magnetic disturbances. From* New Lands Within the Arctic Circle *by Julius Payer, 1876.* COURTESY OF SPECIAL COLLECTIONS, UNIVERSITY OF SASKATCHEWAN

SCIENTIFIC TRAVELLERS AND
THE SOUTHERN LIGHTS

As a young man, Alexander von Humboldt had been introduced to the art of scientific travel by Georg Forster, a geographer and artist who accompanied Captain Cook on his famous journey into the Antarctic (1772–75). Coincidentally, it was on this journey that Cook first reported seeing the southern lights and coined the name "aurora australis."

As subsequent expeditions pushed deeper into the south-polar zone, sightings of the southern lights became common. One winter's night in 1831, for example, the crew of the brig *Tula* found themselves surrounded by icebergs at the Antarctic Circle. "At the same time," their commander reported,

> nearly the whole night, the Aurora Australis showed the most brilliant appearance, at times rolling itself over our heads in beautiful columns, then as suddenly forming itself as the unrolled fringe of a curtain, and again suddenly shooting to the form of a serpent. . . ; [it] was without exception the grandest phenomenon of nature of its kind I have ever witnessed. At this time we were completely beset with broken ice, and although the vessels were in considerable danger in running through it with a smart breeze, which had now sprung up, I could hardly restrain the people from looking at the Aurora Australis instead of the vessel's course.

When the reports of antarctic observers were compared with those from the Arctic, it became clear that major auroras occurred at the same times in both hemispheres. It was not until our own time—1967, to be precise—that it could be shown through aerial photographs that the northern and southern polar lights are often mirror images of each other, dancing around opposing poles in near synchrony.

note, Sabine had accompanied first John Ross, in 1818, and then William Edward Parry, from 1819 to 1820, on their icy quests for the Northwest Passage. Thus, unlike most contemporary researchers, he had actually stood a spellbound watch under the polar lights and had even attempted to check out some of the old auroral theories. On Parry's ship, for example, one mast had been fitted with a metal tip, rather like a lightning rod. The idea was to draw electricity out of the aurora and measure it with a sensitive electro-meter—but none could be drawn.

The Parry expedition spent the winter of 1820 frozen in the ice off Melville Island (latitude 75° north), leaving Sabine and his crew mates with plenty of time to contemplate the night sky. When a particularly spectacular display of the aurora rippled across the sky on 15 January 1821, the ship's young midshipman, James Clark Ross, was moved to poetry:

Transfix'd with wonder on the frozen flood,
The blaze of grandeur fired my youthful blood;
Deep in th' o'erwhelming maze of Nature's laws,
'Midst her mysterious gloom, I sought the cause;
But vain the search! . . .

That same "blaze of grandeur" had fired the blood of many nineteenth-century polar explorers and, through their published descriptions, cast a glow over thousands of armchair travellers back home in Europe. By 1880 the Swedish explorer Adolf Nordenskiold, newly returned from the first successful navigation of the Siberian coast, felt obliged to give an account of the lights even though he had seldom seen spectacular auroras. "This splendid natural phenomenon. . . ," he noted, "is in the popular idea so connected with the ice and snow of the Polar lands, that most of the readers of sketches of Arctic travel would certainly consider it an indefensible omission if the author did not give an account of the aurora as seen from his winter station."

The hype about the lights played directly into Humboldt and Sabine's grand undertaking. In fact, Sabine thought the time might be ripe for an even more glorious scheme—"the greatest scientific undertaking which the world has ever seen." What was needed, he suggested, was not just a string of colonial observatories but also a major research expedition to the southern lights and the south magnetic pole. Second-

"MY SOUL WAS ENTRANCED..."

Nineteenth-century polar explorers were manly men, ready to take on cold, ice, frostbite, hunger and darkness without a whimper. They were also materialists, drawn to the ends of the earth by the promised "fruits of material profit and immortal fame." But let an aurora break out overhead, and they turned into poets and theologians.

For example, American adventurer Charles Francis Hall penned this ecstatic description while he was wintering off the southeast coast of Baffin Island in 1861:

It seemeth to me as if the very doors of heaven have been opened to-night, so mighty, and beauteous, and marvellous were the waves of golden light that a few moments ago swept across the "azure deep," breaking forth anon into floods of wondrous glory. God made His wonderful works to-night to be remembered. . . .

I had gone on deck several times to look at the beauteous scene, and at nine o'clock was below in my cabin going to bed, when the captain hailed me with the words, "Come above, Hall, at once! THE WORLD IS ON FIRE!"

I knew his meaning, and, quick as thought, I redressed myself, scrambled over several sleeping Innuits close to my berth, and rushed to the companion stairs. In another moment I reached the deck, and as the cabin door swung open, a dazzling, overpowering light, as if the world was really a-blaze under the agency of some gorgeously-coloured fires, burst upon my startled senses! . . .

My first thought was, "Among the gods there is none like unto Thee, O Lord; neither are there any works like unto Thy works!" . . . We looked, we SAW and TREMBLED.

Norwegian researcher Fridtjof Nansen had a similar experience in the fall of 1893, when he and his party were frozen into the Arctic ice aboard the vessel *Fram*:

Presently the aurora borealis shakes over the vault of heaven its veil of glittering silver—changing now to yellow, now to green, now to red. It spreads, it contracts again, in restless change, next it breaks into waving, many-folded bands of shining silver, over which shoot billows of glittering rays; and then the glory vanishes. Presently it shimmers in tongues of flame over the very zenith; and then again it shoots a bright ray right up from the horizon, until the whole melts away in the moonlight, and it is as though one heard the sigh of a departing spirit. Here and there are left a few waving streamers of light, vague as a foreboding—they are the dust from the aurora's glittering cloak.

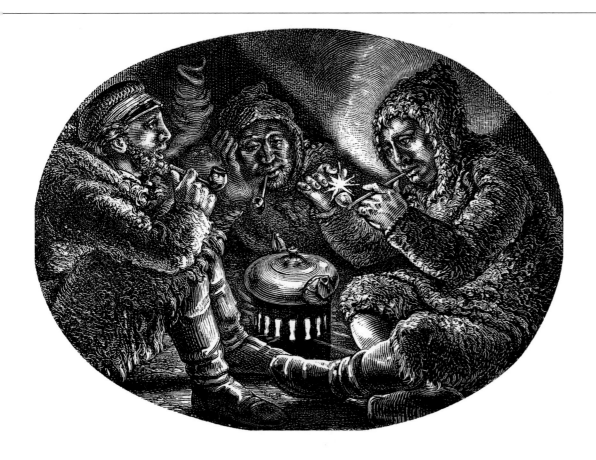

From Voyage aux mers polaires *by J.-R. Bellot, 1880.* COURTESY OF CANADIAN CIRCUMPOLAR INSTITUTE, UNIVERSITY OF ALBERTA

Finally, Robert F. Scott wrote this appreciation of the southern lights while preparing for his final, fatal expedition in 1911:

> The green ghostly light seems suddenly to spring to life with rosy blushes. There is infinite suggestion in this phenomenon, and in that lies its charm; the suggestion of life, form, colour, and movement never less than of mystic signs and portents—the inspiration of the gods—wholly spiritual—divine signalling. Remindful of superstition, provocative of imagination. Might not the inhabitants of some other world (Mars) controlling mighty forces thus surround our globe with fiery symbols, a golden writing which we have not the key to decipher?

In their more matter-of-fact moments, polar travellers also made many important scientific observations of auroral phenomena. Their greatest contribution may have been simply recording the locations at which the lights could be seen. This information was used in the 1860s and 1870s as the basis for maps showing the frequency of auroral observations at various latitudes in the northern hemisphere (see pages 16–17). Corresponding maps for the southern hemisphere could not be drawn until 1945, when adequate observations had finally been compiled.

ed by several other prominent scientists, Sabine proceeded to exercise his considerable talents for backroom politics and, in 1839, claimed his victory. What observers wryly dubbed the "magnetic crusade" was underway, with that erstwhile auroral bard, James Clark Ross, in command of the polar expedition and one Edward Sabine as superintendent of observatories in Toronto, Tasmania and the Cape of Good Hope.

"Never before," chirped Humboldt, "has so noble and cheerful a spirit presided over the inquiry into the *quantitative* relations of the laws of the phenomena of nature."

While the elderly Humboldt basked in self-satisfaction, Sabine (by now a general) marshalled his scientific troops for action. In particular, he had his sights set on disrupting the certainties of Carl Gauss, especially his assumption that earth magnetism was internally generated. Schooled by the experience of watching those "magnetic columns of flame" dance in the polar skies, Sabine thought otherwise. He strongly suspected that some portion of the earth's magnetism arose in the atmosphere, perhaps in response to cosmic influence.

In 1851 Humboldt came up with a piece of apparently irrelevant information that gave Sabine's speculations new meaning. In Germany an amateur astronomer named Samuel Schwabe had been studying the spots, or dark patches, on the surface of the sun. Every day for thirty years, Schwabe scanned the sun with his telescope and counted the sunspots. Year by year he tabulated his data, and year by year a pattern emerged more clearly. The annual number of sunspots traced out a regular wavelike curve that ran from peak to trough about once a decade. (Further study would fix the cycle at close to eleven years.) As the president of the Royal Astronomical Society exclaimed when he gave Schwabe his gold medal some years afterwards, "the energy of one man has revealed a phenomenon that had eluded even the suspicion of astronomers for 200 years!"

Schwabe's result was just what Sabine had been waiting for. Rifling through millions of bits of accumulated data (all this before the invention of computers), he uncovered a stunning correspondence. When he charted the annual number of magnetic storms recorded by the colonial observatories, his graph showed the same cyclic ups and downs as Schwabe's sunspot numbers.

Sabine reported this result with triumphant conviction in 1852. "The discovery of a connexion of this remarkable description" validated both his intellectual passion and his political connivings; it stood in justification of his life's work. But his scientific col-

OPPOSITE: *Norwegian explorer and diplomat Fridtjof Nansen created this woodcut to commemorate his long months aboard the research vessel* Fram. *Nansen attempted to reach the north pole by sailing into the Arctic Ocean and deliberately allowing his ship to freeze into the ice. As the ship drifted slowly northward, Nansen had plenty of time to reflect on the grandeur of the northern lights.* SCOTT POLAR RESEARCH INSTITUTE

leagues, with less need for certainty, were correspondingly less certain. Sabine's parallel graphs were curious but, in the final analysis, they didn't prove anything. Even assuming that the correlation was real (Sabine had once been accused of fudging data), there was no hint of a mechanism, no plausible chain of cause and effect that could connect changes in the sun with happenings near earth.

What scientists cannot understand, they are inclined to discredit, and so it was with Sabine's "connexion." In 1859, the year Humboldt died, an astronomer named Richard Carrington of the Kew Observatory in London made the first excited observation of a solar flare—"two patches of intensely bright and white light [that] broke out" from the surface of the sun. Carrington noted that this spectacular "conflagration" was followed eighteen hours later by "a great magnetic storm, which subsequent accounts established to have been as considerable in the southern as in the northern hemisphere." Huge auroras blazed above Hawaii, Jamaica, Cuba, Guadeloupe, Chile and Australia. In France telegraphic communications were disrupted—sparks flew from the lines; in New England it was possible for several hours to send messages without battery power, using electric currents that suddenly began to flow through the wires. But Carrington "would not have it supposed that he even leans towards hastily connecting" these events. "One swallow does not make a summer," he said coolly.

Whatever the misgivings of orthodox scientists, evidence of a solar connection continued to gather. In the 1870s researchers in the United States and Germany scanned the historical record, counted the number of auroras reported for each year and graphed their results. (Since most auroral observers were stationed in mid-latitudes, this data emphasized major auroral outbursts—the times when the lights spilled out beyond the polar regions.) Sure enough, the frequency of these widespread displays followed roughly the same eleven-year rise and fall as that of sunspots and magnetic storms. Additional confirmation was provided in 1905 by the husband-and-wife team of Edward Maunder and Annie S. D. Russell ("lady computer") at Greenwich Observatory. Again the correlation was direct and surprisingly orderly: more sunspots, more magnetic storms, more spectacular aurora; fewer sunspots, fewer magnetic disturbances, fewer curtains of polar light. The burning question was *why*.

This was a question for which the classical pinball physics of Isaac Newton—mass A hits mass B with force C—had no ready answer. But in the mid-decades of the nineteenth century (while Humboldt and Sabine were roaming the world on their epic

THE PROGRESS OF SCIENCE

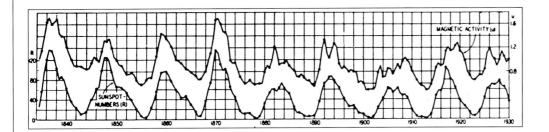

Edward Sabine's assertions about the aurora had the virtue of being correct. But to his contemporaries they were just another entry in the crowded field of auroral hypotheses. In his book *Majestic Lights*, Robert H. Eather lists twenty-seven theories that were under serious consideration by scientists in the nineteenth century—all of them supported by argument and almost all of them wrong. The contending notions ranged from the old-fashioned idea of reflected sunlight to the advanced concept of currents in the interplanetary medium. According to rival theorists, the aurora correlated exactly with one or more of a large number of phenomena, including clouds, thunderstorms, wind patterns, air pressure, temperature gradients, sea coasts, earthquakes, volcanoes, moon phases, lunar haloes, shooting stars, meteoric dust, telluric currents, atmospheric electricity and the movements of other planets.

Into this hubbub came Sabine, with his contention that the aurora was linked to certain dark spots on the sun. For the moment, his claims did little more than add to the confusion.

This graph shows the correlation between the number of sunspots (bottom line) and the number of magnetic storms (upper line) between 1830 and 1930. From Terrestrial Magnetism and Atmospheric Electricity 37 (1), *1932.*

field research), a small group of stay-at-home thinkers had begun to invent a revolutionary new physics. The science of electromagnetism, as the new theory became known, depicted a through-the-looking-glass world in which one mass could directly affect another without touching it, one force could spontaneously create another of a different sort, and ordinary matter could give off light.

This strange reality had first revealed itself in a lecture hall at the University of Copenhagen in 1820, when a natural philosopher named Hans Christian Oersted set up an electric circuit and held a compass near the wire. When the current was flowing, the compass needle registered a magnetic disturbance. A thoroughgoing Romantic with a passionate belief in the fundamental unity of natural forces, Oersted deduced from this observation that electric currents give rise to, or induce, magnetic effects. Eleven years later, Michael Faraday, a self-taught research assistant at the Royal Institution in London, demonstrated the opposite process. By subjecting a copper wire to a changing magnetic stress, he caused an electric current to flow through the circuit. Magnetic forces, he observed, can give rise to electric currents—a discovery the ever-practical Faraday put to work by inventing the dynamo.

It was clear to Faraday, as it had been to Oersted, that electricity and magnetism were twin aspects of the same universal force. But Faraday pushed his thinking deeper. Electromagnetism, he said, must be a kind of radiant energy that travels in waves or vibrations. This energy can be dispersed through space, like light around a lantern. Thus, when iron filings are sprinkled around a bar magnet, they trace out a pattern of lines of force that loop from pole to pole. This is because the magnetic energy is held by the field, or space, surrounding the magnet.

And that was not the end of Faraday's mind-bending work. By 1846 (despite a nervous breakdown caused by long years of intellectual effort), he had become convinced that light was also a manifestation of electromagnetism. This radical (and correct) concept had been forced upon him, in part, by experiments with gas-discharge tubes—those mysterious vessels of rarefied air that magically began to glow when an electric current was passed through them.

Could these new ideas help to explain the polar lights? By the 1880s, a Finnish physicist named Karl Selim Lemström was more than ready to try. Still unwilling to acknowledge the possibility of solar influence, Lemström believed the aurora was caused by inner-earth magnetism, which (by some unspecified mechanism) induced

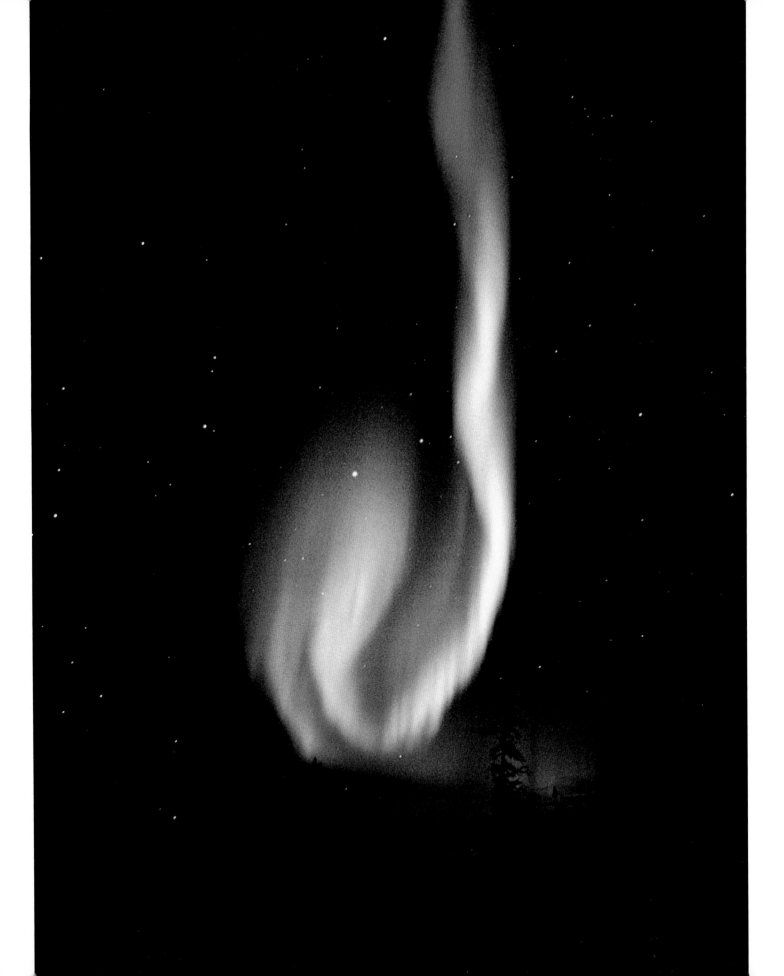

"Now the aurora shoots up in beams Who but God could conceive such infinite scenes of glory?" From Life with the Esquimaux *by Charles Francis Hall, 1865.*

THE PHYSICS OF ANGELS

Madame Helena Petrovna Blavatsky (1831–91) was a shameless charlatan. The cofounder of the international Theosophical Society, she dazzled her followers with lies and "psychic" tricks and was finally exposed as a fraud. All the same, she was one of the most forceful and idiosyncratic thinkers of the nineteenth century, bringing a unique perspective to such diverse subjects as Eastern mysticism, Western physics—and the aurora.

Madame Blavatsky's intellectual ambition was to reconcile ancient spiritualistic traditions with modern materialistic science. She did so by envisioning physical matter as an expression of immaterial force, a concept that Einstein would later work out in mathematical form. But where Einstein defined the underlying force as "energy," Blavatsky understood it to be "spirit." In her most important work, *The Secret Doctrine* (1888), she described this spirit as an animating consciousness that produces the "waves and undulations of Science" by propelling atoms and molecules into movement "from within." "It is that inner work that produces the natural phenomena called the correlation of Forces," she wrote. "Only, at the origin of every such 'force,' there stands the *conscious* guiding noumenon thereof—Angel or God, Spirit or Demon." Thus each atom is energized by its own spark of spirit and thereby generates forces that science describes as gravitation, radiation, magnetism, etc.

According to Blavatsky, the mystical basis of physical phenomena is known only by the seers—those rare individuals who perceive spirits as dazzling specks of light. These radiant epiphanies are "swifter than thought," she said, "quicker than any mortal physical eye could follow. . . . Standing on an open plain, on a mountain summit especially, and gazing into the vast vault above and the spacial infinitudes around, the whole atmosphere seems ablaze with them, the air soaked through with these dazzling coruscations. At times, the intensity of their motion produces flashes like the Northern lights." Thus physics and spiritualism combined in Madame Blavatsky's exotic mind to produce a vision of the aurora as atoms of angel light.

TOP: *Karl Selim Lemström erected this apparatus on a mountaintop in northern Finland in an attempt to create an artificial aurora.* BOTTOM: *An even larger apparatus was erected by the French researcher C. X. Vaussenat in 1884. Despite the labour invested in the undertaking, Vaussenat was unable to replicate Lemström's findings.* COURTESY OF ROBERT H. EATHER

electric currents to flow through the atmosphere. This electricity, he claimed, streamed up into the night sky and caused the air to glow, just as it did in the discharge tubes in his laboratory. But Lemström knew that lab trials were not enough to prove his theory, so he packed up his equipment and freighted it from Helsinki all the way to Sodankyla in Finnish Lapland. There, at the top of a tall hill, he erected an immense *utströmnings* (discharging) apparatus—several hundred metres of copper wire armed with iron points and laid over telegraph poles, the whole thing arranged in a spiral. This device was connected by another wire to a disk buried in the earth at the base of the mountain.

Not only did a current flow through the wire, as Lemström had predicted, but he swore that he saw a faint yellow-white light above his setup. Leaving nothing to chance, Lemström had this glow analyzed by spectroscopy—a new (and still highly unreliable) technique for identifying gases by studying the light they emit. To his immense satisfaction, his light was declared identical to that of the aurora borealis.

Lemström confidently affirmed that the case was closed. But when other investigators attempted to repeat his experiments, they were unsuccessful. For example, an especially large discharging device (more than twice the size of Lemström's apparatus) was erected by French scientists but produced no results except for violent electric sparks near the wire that left the investigator with burned eyebrows and eyelashes, singed clothes and a broken watch!

And so things stood as the century waned. For nearly three hundred years, scientists had aspired to claim the auroral crown. One after another, earnest and worthy thinkers had struggled to unravel the riddle; one after another, they had failed. Then, in 1896, a new contender arrived on the scene. His name was Professor Kristian Birkeland of Christiania, Norway, and, at first glance, his chances of success did not seem promising. But, as the aurora itself had so often shown, first impressions can be very wrong.

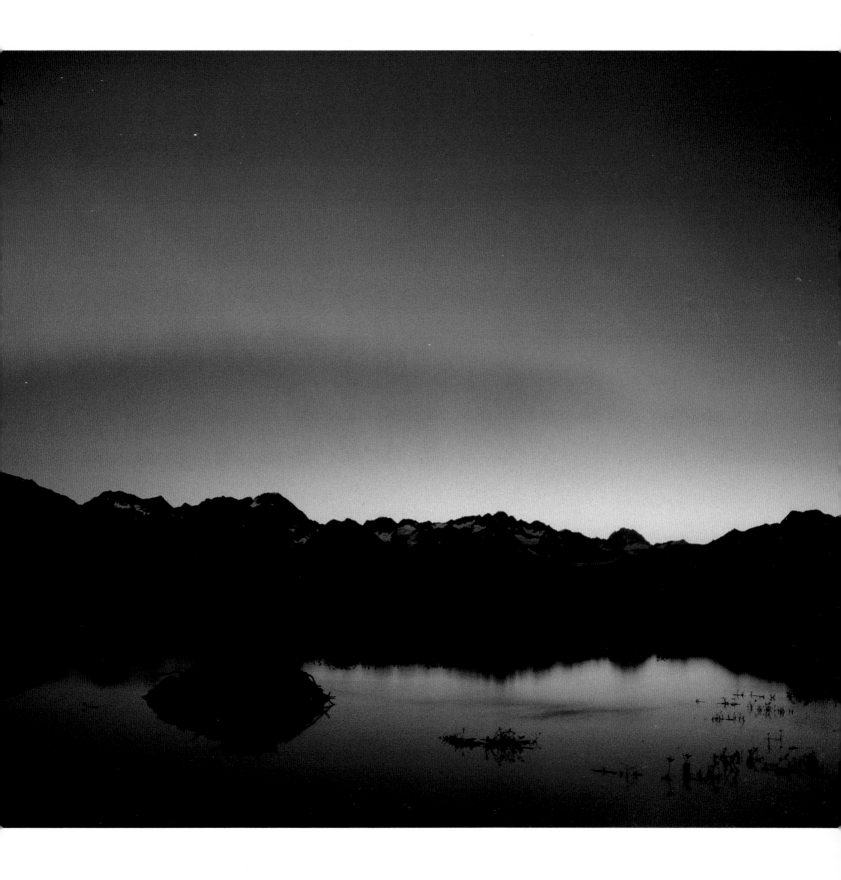

Like the dummkopf hero in a folk story, Kristian Birkeland was a less-than-imposing figure. Weak-eyed and portly, with a high forehead and a soup-strainer moustache, he was affectionately remembered by one of his associates for operating "scarce electrical lecture equipment far beyond its rated capacity and [burning] out 100 Amp fuses with dignified nonchalance. Then he would stop and in a royal manner untie the ruffles in the sleeves of his jacket and dry his glasses in order to improve his view of his last miscalculation on the blackboard."

In a similar vein, Birkeland himself liked to tell of the day he demonstrated one of his inventions—an electromagnetic gun—to the largest arms manufacturer in Europe.

CHAPTER 5 THE LAST FRONTIER

I went through the principles on which the gun was based and "Ladies and Gentlemen," I said, "you may calmly be seated. When I push the switch on, you will neither see nor hear anything except the bang of the projectile against the target." With this I pushed the switch on. There was a flash, a deafeningly loud hissing noise, a bright arc of light caused by three thousand amperes being short circuited, and a flame shot out of the mouth of the gun. Some of the ladies shrieked and a moment later there was panic. It was the most dramatic moment in my life—with this one shot, I shot my stock down from a value of 300 to zero. But the projectile hit the bulls eye.

Birkeland's auroral theories, on the other hand, were not quite on the mark. But, unlike his predecessors, he was at least turned to face the target.

An ardent student of electromagnetism, Birkeland brought the last word in theory and experiment to his thinking. In 1896, when Sir William Crookes in England demonstrated that a stream of "cathode rays" in a gas-discharge tube could be deflected by a magnet, Birkeland immediately put the idea to work. Could it be, he wondered, that streams of cathode rays—or electrons, as they were soon to be known—were emitted from sunspots and flooded through space towards earth? Per-

OPPOSITE: *Kristian Birkeland, left, has been called the father of modern auroral science. Here, he and his assistant oversee an experiment in which beams of electrons pass through a vacuum chamber and towards a magnetized sphere.* COURTESY OF ROBERT H. EATHER AND ALV EGELAND

This cartoon was published to commemorate the spectacular misfiring of Birkeland's electromagnetic cannon. The huge sparks that flew from his gun subsequently became the basis of Birkeland's most successful invention—an electrical method of producing nitrogen fertilizer.

haps these outpourings of electrons were ultimately caught by the earth's magnetic field and directed towards the poles. Then, as the electrons flowed through the thin air of the upper atmosphere, they would cause the gases to glow, just as happened in discharge tubes in the laboratory. At the same time, these streaming electrons, or currents, in the atmosphere could be expected to induce magnetic disturbances, or storms. The changing magnetic fields would, in turn, induce electrical currents in the earth and in above-ground conductors such as telegraph wires and Lemström's apparatus.

It was an elegant theory that accounted for many features of auroral phenomena. All that it lacked was evidence. So, drawing on the profits of his commercial inventions (including such homely items as hearing aids, electric blankets and techniques for producing margarine), Birkeland constructed a series of elaborate models in his laboratory. These featured a magnetized sphere, to represent the earth, which was suspended in a partial vacuum, or the upper atmosphere. When this apparatus was bombarded with electrons—lo and behold—bright rings of light began to glow in the fluorescent surface around the globe's north and south poles.

Then, to clinch his case, Birkeland headed north, establishing research stations in such hospitable locales as Iceland, Spitsbergen and Novaya Zemlya. On his first outing, in 1897, he and his party lost their way, and almost their lives, in a blizzard. During the winter of 1899–1900, his research station on a mountain top in the Finnish Arctic was blasted by fierce winds and ferocious cold. Water froze "a couple of yards from a glowing stove; and the lamp was blown out on the table in the middle of the room." But through all these difficulties, Birkeland and his colleagues were warmed and excited by the results of their research. Their data provided strong evidence that both the aurora and magnetic storms "might be naturally explained as the effect of electric currents" with their origins in the sun. The competing auroral theories of earlier times—magnetic, electrical and cosmic—had come to rest in one.

Birkeland unveiled his auroral theory in the early years of the new century. In several hundred carefully documented pages, he showed how electrons emitted by the sun might careen freely through space until they ran into the earth's magnetic field. Trapped by these magnetic forces, the particles would be pulled sharply off course and sent spinning down towards the skies of the polar regions. As the electrons rained into the atmosphere, they would strike the gases there and cause them to give off light, bringing the sky to life with soft auroral forms. The electrons would flow east or west

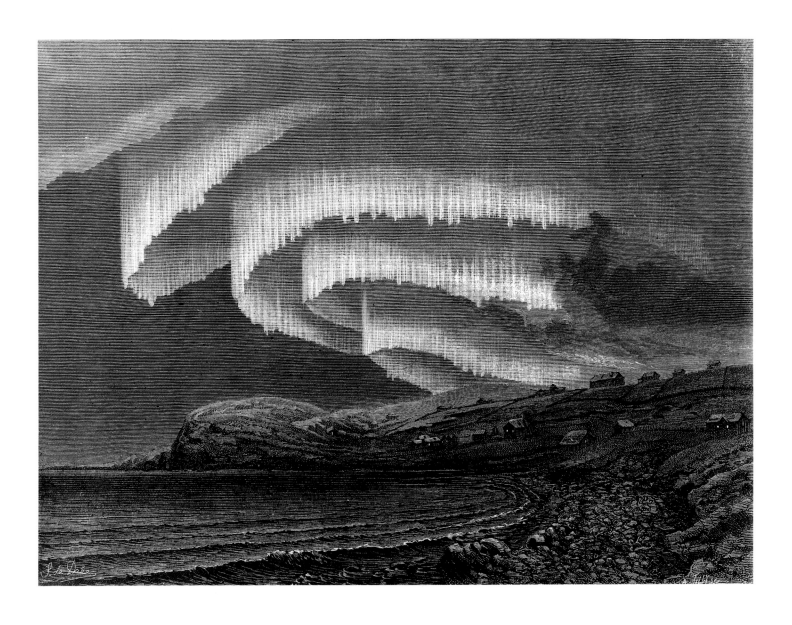

This lovely engraving shows an aurora observed by a research team at Bossekop, Norway, in January 1839. *From* L'Aurore Boréale *by M. Lemström, 1886.* COURTESY OF HARVARD COLLEGE LIBRARY

Although the forms and features of the northern lights were documented in the 1800s, serious investigation of the southern lights was not undertaken until the early years of our own century. This sequence of exotic configurations was observed during an Australian expedition to Antarctica, led by Douglas Mawson in the early 1900s. From Australasian Antarctic Expedition 1911–14 *by Douglas Mawson, 1925.*

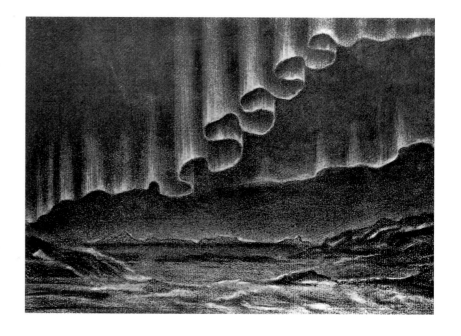

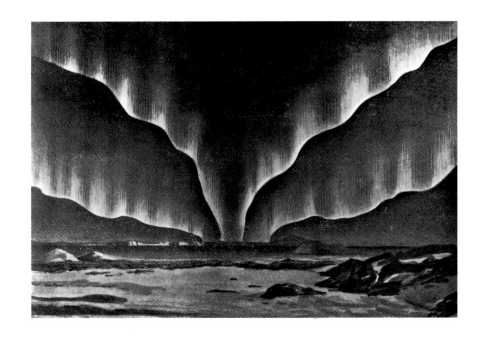

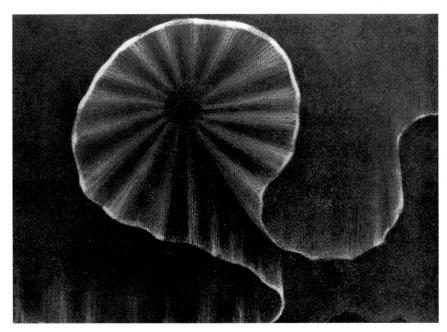

along the base of the curtains and then climb back up the earth's magnetic field, towards some unknown fate in the outer darkness.

Birkeland's explanation was a blockbuster, and he confidently prepared for his moment of triumph. But the triumph did not come. Almost to a man, Birkeland's scientific colleagues rejected his ideas and his evidence. As one of them candidly acknowledged, "the limits to allowable heterodoxy in science are soon reached," and Birkeland was far beyond the pale. For one thing, the link between the sun, earth magnetism and the aurora was still not universally accepted. In fact, no less a personage than Lord Kelvin, the pre-eminent British physicist of the time, claimed to have "absolutely conclusive [evidence] against the supposition that terrestrial magnetic storms are due to magnetic action of the sun." The "supposed connection between magnetic storms and sunspots is unreal," he asserted, "and the seeming agreement between the periods has been mere coincidence." Enough said.

As Samuel Pierpoint Langley had pointed out in his 1899 address as retiring president of the American Association for the Advancement of Science, the scientific community is "not wholly unlike a pack of hounds . . . where the louder-voiced bring many to follow them nearly as often in a wrong path as in a right one." Lord Kelvin spoke with a very loud voice.

There were other more technical objections to Birkeland's avant-garde thinking. Suppose, just for the moment, that the sun did spew out streams of electrons. How could they travel through empty space, with no conducting medium to support them? And wouldn't the beams of electrons break up, because the particles all carried the same charge and, hence, repelled each other? Finally, as the electrons neared the end of this impossible journey, how would they manage to flow through the atmosphere? Although a few cranks and visionaries had begun to suggest that the upper atmosphere might be electrically active, it was widely accepted that air was neutral and incapable of conducting electrical currents.

Birkeland was at a loss for answers. Grasping at straws, he suggested that the electron beams stayed intact by travelling at the speed of light, so fast that repulsive forces between the electrons did not have time to act. At this rate, they would reach the earth in a matter of minutes. Then why, his critics wondered, did it take hours or even days for a solar flare, with its supposed outpouring of particles, to trigger auroral outbursts? Again Birkeland had no response.

Birkeland died in 1917 at the age of fifty, broken in spirit and in intellect, disheartened by the harsh reaction to his theory or, perhaps, poisoned by mercury, which was commonly and carelessly used in nineteenth-century laboratories. (The same affliction may have taken the life of Faraday.) His passing left the arena open to the next aspiring candidate, a cheerfully eccentric young English physicist named Sydney Chapman. Gifted with a mischievous smile and exuberant energy, Chapman gambolled onto the scene with a theory that, in many ways, resembled Birkeland's and that, predictably, received the same drubbing. Perhaps the sting of this criticism turned Chapman away from Birkeland's work towards the safety of greater orthodoxy. Or perhaps he was put off by the personal habits of Birkeland's scientific successor, a Norwegian physicist named Carl Störmer, who occasionally enjoyed snapping clandestine photographs of young women whom he found "temptating." A Victorian by birth and temperament, Sydney Chapman was not amused by Störmer's antics.

For whatever reason, the young Chapman, who was destined to become the leading auroral theorist of his generation, turned his back on important aspects of Birkeland's theories. In particular, he rejected the notion of electrical currents that followed the earth's magnetic field into the atmosphere. But, to his credit, he did not abandon the unfashionable search for a missing link between the earth and the sun. Indeed, the evidence for such a connection was constantly growing. In 1904, for example, Edward Maunder had discovered that magnetic storms tend to recur at 27-day intervals. As Maunder was quick to point out, this is just the time it takes for the sun to complete one rotation relative to the earth.

Strong auroras were later found to exhibit the same 27-day return. If a brilliant aurora was visible at a certain latitude around, say, 1 January, a similar display could be expected on or about 28 January, 24 February, and so on. The cycle often persisted through three or four repetitions, but it could continue for up to ten rotations. It was as if there were active areas on the sun that spewed out jets of matter, much as the nozzle of a rotating sprinkler sprays out streams of water. When the solar nozzle was pointed towards earth (once in 27 days), the jets impacted the planet, causing enhanced aurora and magnetic spasms.

But what might those jets contain? They could not simply consist of electrons, because a beam of negative particles would tear itself apart. From 1918 on, Chapman found himself drawn to an obvious, though untestable, alternative. What if the sun

AURORAL HEIGHTS

The height of the aurora had long been a contentious question, much chewed over by competing theorists. Lemström, for example, insisted that the lights hovered close to the ground. Birkeland, on the other hand, argued that they must be at a greater distance. Unfortunately, no one had been able to settle the issue.

It was not for lack of effort. From 1730 on, numerous investigators had attempted to determine the height of the aurora by triangulation. This involved measuring the angle between the observer's eye and a particular spot on the bottom of an auroral curtain. At the same moment, a measurement had to be made by another observer, several kilometres distant, and keyed to the same spot on the aurora. Before the invention of the telegraph, it was virtually impossible to achieve this degree of co-ordination. Even when communication became possible, the slithery ribbons of light were hard to pin down with any precision. Not surprisingly, estimates of minimum heights varied wildly—from ground level to 1600 kilometres.

The problem was solved in the early 1900s by a protégé of Birkeland's, a physicist and amateur photographer named Carl Störmer. The first person to master auroral photography, Störmer and his coworkers produced more than 40 000 images, many of them matched sets taken from different locations. On the basis of this evidence, Störmer established that the lower edge of most auroral displays stands at between 90 and 150 kilometres above earth. This puts them at about ten times the height of the highest clouds or of a cruising jet.

Carl Störmer, left, and his assistant posed for this picture of their auroral photography equipment in 1910. Like all serious aurora watchers, they are thoroughly outfitted for winter. COURTESY OF ROBERT H. EATHER AND ALV EGELAND

THE BALLAD OF THE NORTHERN LIGHTS

This photograph, said to be the first image of the aurora recorded in Canada, shows the northern lights blazing over Dawson. Such a sight must have been familiar to the Yukon's most famous versifier, Robert W. Service, who was inspired to write a long yarn about the "mystic gleam" of the aurora. In a closing stanza of his poem, Service not only reveals the true nature of the phenomenon, but also makes an unprecedented offer:

Some say that the Northern Lights are the glare of the Arctic ice and snow;
And some that it's electricity, and nobody seems to know.
But I'll tell you now—and if I lie, may my lips be stricken dumb—
It's a *mine*, a mine of the precious stuff that men call radium.
It's a million dollars a pound, they say, and there's tons and tons in sight.
You can see it gleam in a golden stream in the solitudes of night.
And it's mine, all mine—and say! if you have a hundred plunks to spare,
I'll let you have the chance of your life, I'll sell you a quarter share.

"Dawson by the light of the aurora borealis" was created by Jerry Doody in 1908.
COURTESY OF RCMP
MUSEUM, REGINA

PLASMA

Everyone is familiar with the idea that there are three states of matter—solid, liquid and gas—exemplified in everyday life by ice, water and steam. But there is also a fourth state, more diffuse than an ordinary gas, that (by analogy with the thin soup within human blood) has been given the name of plasma. Down here on earth, plasmas occur only in human-made devices such as neon lights, mercury-vapour lamps and laboratory apparatus. But elsewhere in the universe, plasmas are common. As much as 99.9 per cent of the matter in the cosmos is thought to exist in the plasma state. This includes not only matter in the sun, the stars and space, but also in the outer atmosphere, the earth's magnetic field and the solar atmosphere—all the regions that are involved in producing the aurora. The polar lights offer us a glimpse into the complex workings of the plasma universe and provide us with a natural laboratory in which it can be studied.

gave off not just electrons, but electrons and protons—negative and positive charges—in equal quantity? In that case, the attraction between unlike charges would compensate for the repulsion between like ones. To use more modern vocabulary, Chapman began to wonder if the sun might emit matter in the form of a "plasma," a very thin, highly ionized, electrically neutral gas.

This apparently simple idea took over Chapman's scientific life. By 1933 he and a colleague had worked it out mathematically—with startling results. Ever since 1600, when William Gilbert first recognized the earth's magnetic properties, it had been assumed that the planet's magnetic field resembled that of an ordinary bar magnet. As everyone knows from grade-school experiments, the field of a bar magnet is shaped into two symmetrical, semicircular lobes, rather like the cross-section of an apple. The cheeks of the apple consist of curved lines that link the magnet's north and south poles. These are called "closed" lines because they loop from pole to pole. In addition, a spray of lines extends outwards from both the top and bottom of the magnet. These are called "open" lines because they trail off into space. The earth's magnetic field had long been envisaged as a three-dimensional version of this familiar shape.

Chapman's math opened the window on a strange new reality. If the earth were bombarded by streams of plasma from the sun, his calculations predicted that the planetary magnetic field would act as a barrier to the flow, like a boulder in a river. On the day side of earth, facing the sun, the magnetic field would be compressed when the solar stream slammed into it. But on the night side, as the plasma swept past, the field would be dragged out into a long, tapering tail that reached for hundreds of thousands of kilometres. And the influence would not be one-sided. As the solar particles sculpted and shaped the earth's magnetic landscape, they would be reciprocally shaped and guided by it. Under the push and pull of electromagnetic forces, solar electrons and protons would be constrained to flow in vast electrical currents that circuited the earth at heights of several thousand kilometres. These ring currents, the theory said, carried fluctuating magnetic fields that produced magnetic storms.

So far so good. But where did the aurora fit in? Chapman wasn't sure. But he did know from recent work by other scientists that the upper atmosphere, or ionosphere—the layer in which the polar lights appeared—was an excellent conductor of electricity. So he and his colleagues did the math to show how elaborate systems of auroral currents might flow through the ionosphere. Was there a connection between these theo-

OVERLEAF: *The turbulent vitality of the aurora is the result of equally turbulent forces at work in space, between the earth and the sun.*

LEFT: NORBERT ROSING;

RIGHT: DAVE PARKHURST

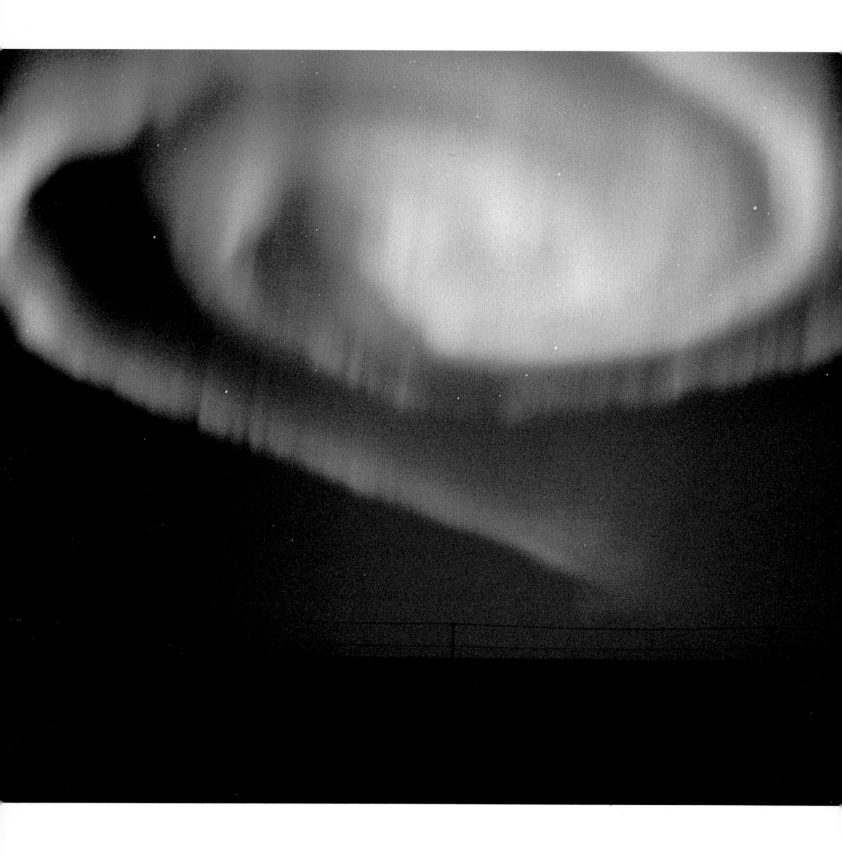

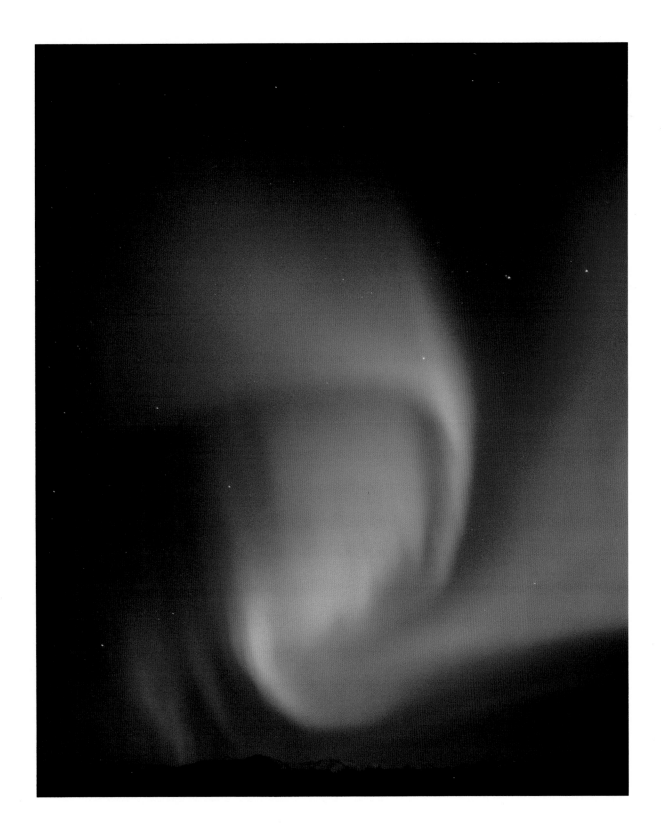

These rather fanciful all-sky views of the northern lights were created by members of an American scientific expedition to Franz Josef Land, north of Siberia, in 1904. From The Ziegler Polar Expedition, 1903–1905 *by Anthony Fiala, 1907.*

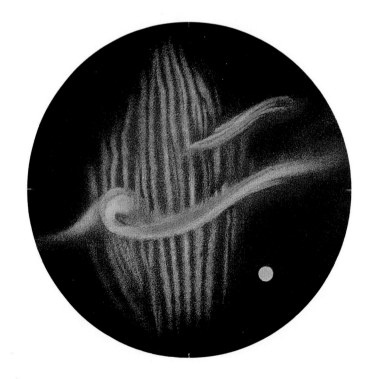

retical currents, swirling over the poles, and the equally theoretical effects of solar streams in the earth's far-distant tail? As Chapman saw things, such a link was so unlikely that it was hardly worth considering.

But there was one young upstart who dared to challenge the master's thinking. A gloomy-looking man with basset-hound eyes, Hannes Alfvén was scarcely into his thirties when he published his own auroral theories. A mere engineer (of all things) from Stockholm (of all places), he was intent on reviving and updating certain banned ideas from the work of fellow Scandinavian Kristian Birkeland. Alfvén claimed he could show how the solar streams and the earth's dragged-out magnetic field functioned as a generator that pumped currents of electrons in and out of the upper atmosphere. There the currents caused the lights to dance, much as Birkeland had predicted. Thus, the aurora and the solar streams were not separate, as Chapman's math implied, but instead were intimately connected.

Try as he would, Alfvén could not get a hearing for his ideas. Major journals refused to publish his work because it was out of sync with Chapman's thinking. The old man himself wrote off Alfvén's theory as "curious" and refused to discuss it. Chapman hated controversy; Alfvén thirsted for it. (He eventually fled his homeland for the United States after scrapping with the Swedish government on such diverse topics as education and the design of nuclear reactors.) When Alfvén presented a paper at a scientific meeting, Chapman would rise to say that he disagreed and planned to publish his objections in a forthcoming paper. "Alfvén protested," a witness recalls, "but Chapman sat down and would not debate." And so it went through the 1940s and into the 1950s.

It was a stalemate. The only way to break the jam was by collecting evidence to support or refute the contending theories. But how was such data to be obtained? In the old days, when the aurora was thought to be a local, terrestrial phenomenon, it had seemed sufficient to climb a mountain or journey to the Arctic to study it. But now the field of inquiry had expanded to include the ionosphere, the magnetosphere (as the earth's magnetic field was soon renamed) and the solar atmosphere—at distances of 100 to 150 million kilometres above the planet. Collecting measurements from that vast and inhospitable region seemed a task best suited to Jules Verne.

Science fiction became science fact at the hands of the German military. During World War II, the Reich employed Werner von Braun and his team of rocket specialists

OVERLEAF: *The sky near Churchill, Manitoba, is flooded with rivers of light.*
NORBERT ROSING

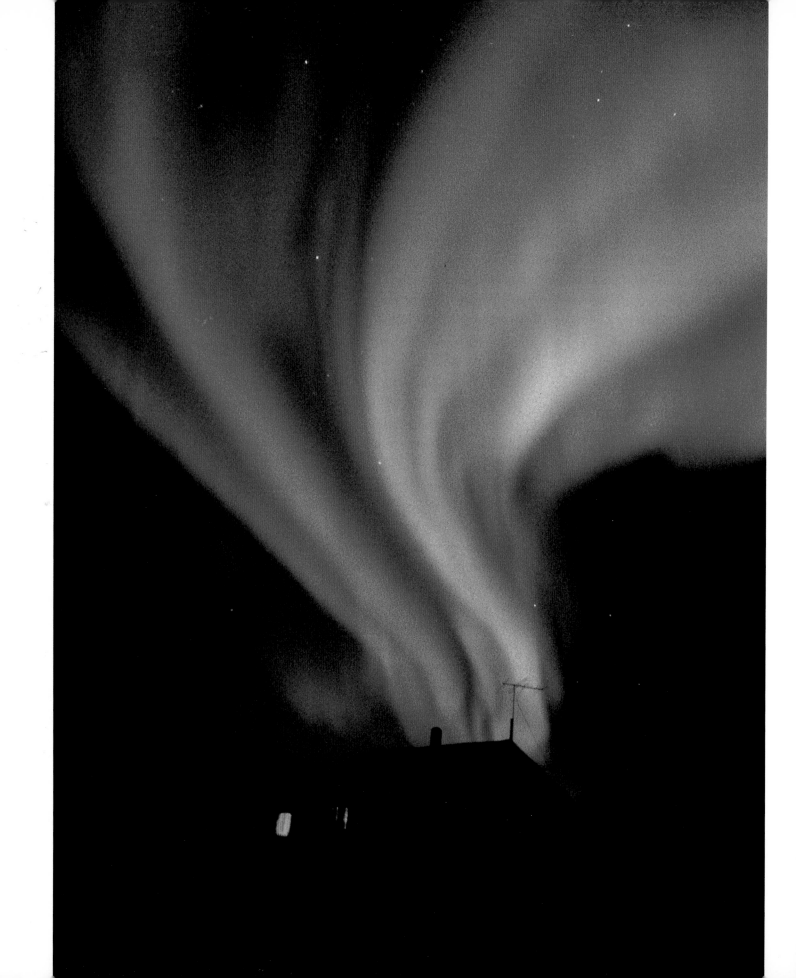

in the production of the world's first long-range missiles. Their most terrifying creation was the V-2, the *Vergeltungswaffe* (Vengeance Weapon), which was used with deadly effectiveness against Britain. But the rocket scientists were not wholeheartedly devoted to military purposes. Their private ambition was to achieve space flight. Indeed, von Braun was once arrested by the Gestapo on the suspicion of just such divided loyalties.

When the war ended, the V-2, its blueprints and its creators became the most sought-after spoils of war. As it turned out, the major beneficiary was the United States. One member of the German rocket team explained, "We despise the French; we are mortally afraid of the Soviets; we do not believe the British can afford us; so that leaves the Americans." Thus it was that in May of 1945, the scientists came out of the woods, hands in the air, and surrendered themselves to an American private on road patrol. As Walter A. McDougall explains in his history of the space age, the U.S. also had the good fortune to capture the Mittelwerk, the secret factory where the rockets were manufactured: "There, on railway cars leading into the bowels of the earth, were gigantic rockets lined up like imports from Mars. And inside, a gutted mountain, bizarre machinery, slaves like living skeletons: a scene from Flash Gordon. Nearby they found the workers' camp and thousands of corpses stacked here and there as garbage awaiting pickup."

From these macabre ruins the American command managed to extract enough components for one hundred rockets, which were transferred to the United States and fitted out for duty in atmospheric research. At last scientists had a means of lifting their instruments to precise locations in the zone where the aurora occurred. Whatever they may have thought of the provenance of the new technology, they leaped at the opportunity to use it. In 1957 the United States Army opened a rocket range in Churchill, Manitoba, halfway up the western shore of Hudson Bay. Under the management of various American and Canadian agencies, Churchill would serve as a world centre for auroral rocketry for almost three decades.

But the very year the Churchill base was opened, it was already on its way to becoming obsolete. On 4 October the U.S.S.R., making the most of its meagre share of wartime rocket-loot, boosted the first artificial satellite into earth-orbit. As American space scientist James van Allen fretted in his notebook, this gave the Russians "a very great scientific lead . . . for cosmic rays, aurorae, etc." But their advantage didn't last long, because within a few months the Americans had launched the first of their

Explorer satellites. The space age had begun, and the realm of the polar lights was finally within reach.

Over the preceding sixty years, auroral theoreticians had posed some big questions. Did plasma really stream towards earth from the sun? Was this material actually deflected by the earth's magnetic field? Did the field become distorted and stretched in the process? Did this drawn-out magnetosphere contain charged particles? Did some of these particles flow in and out of the ionosphere to cause the aurora?

One by one, the spacecraft beeped out the answers. In 1961 *Explorer 14* crossed the outer boundary of the magnetosphere: the distorted earth field was real. A year later *Mariner 2* made the first measurements of solar plasma—the solar wind—gusting through the universe. By 1974 data from *Explorer 12* had been used to confirm the presence of Birkeland's currents, flowing between the magnetosphere and the upper atmosphere.

Sixty years after the fact, the wacky old Norwegian had been proven correct. When Hannes Alfvén went to pick up his Nobel Prize in 1970, he must have wished he could shake the hand of Kristian Birkeland.

EYES ON THE SKIES

In the old days, everything we knew about the aurora came from watching it. Today, by contrast, the visible phenomenon is virtually irrelevant to most scientists. New knowledge is based on data from spacecraft rather than on sightings by ground-based observers.

But there is still an important role to be played by amateur aurora watchers. They can help to maintain the record of visible aurora that has been kept, in one form or other, since the beginning of history. The Aurora Section of the British Astronomical Association collects reports from trained observers in Canada, the United States, Iceland, Britain and various European countries. Reports from the southern hemisphere are maintained by the Aurora Section of the Royal Astronomical Society of New Zealand. These organizations also monitor the effect of the aurora on radio transmission and gather data on magnetic storms and noctilucent clouds. For more information, write to R. J. Livesey, Director, Aurora Section, British Astronomical Association, Flat 1/2, East Parkside, Edinburgh EH16 5X6, or the Royal Astronomical Society of New Zealand, P. O. Box 3181, Wellington, New Zealand.

A fleet of Bombardiers prowls
beneath the southern lights in the
service of auroral research.
WORLD DATA CENTER C2 FOR
AURORA, TOKYO

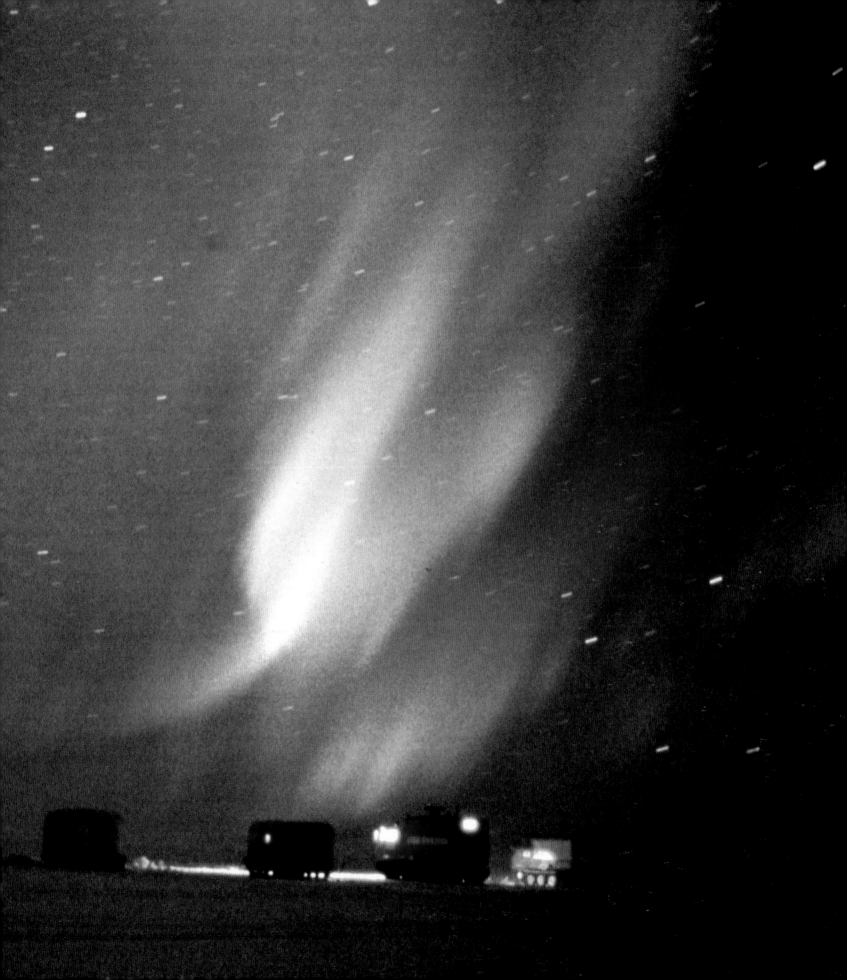

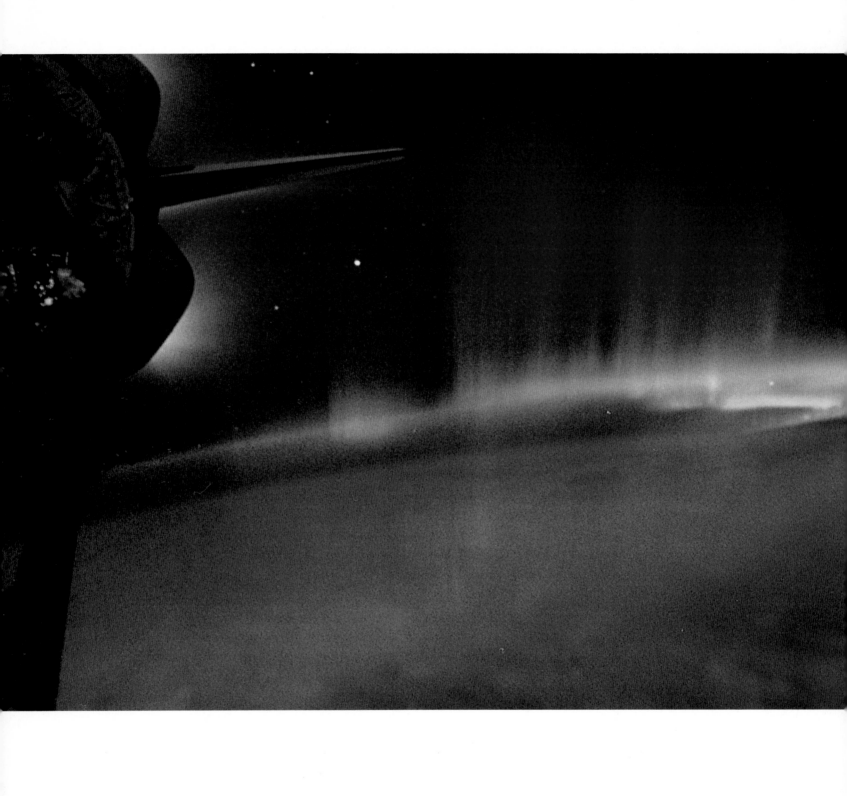

"You must not know too much, or be too precise or scientific about birds and trees and flowers," Walt Whitman once noted. "A certain free margin . . . helps your enjoyment of these things"—as it does of the aurora. Fortunately, modern auroral science is less deadening than many other branches of technical knowledge. Instead of reducing our vision, it enlarges it. Instead of sapping our spirit, it reminds us of cosmic powers. Instead of dulling us with certitude, it has the saving grace of ignorance in the face of the remaining mysteries.

Space-age physics views the aurora as the offspring of an energetic and tempestuous coupling between the earth and the sun. Although we experience the sun as a stable and reliable source of radiation, it is in some ways wildly tumultuous—its fiery

. . . *this beautiful branch of geophysics.*

—*W. N. Abbott, physicist, 1968*

CHAPTER 6 AURORAL GLORIES

surface constantly roiled by turbulence. As the sun rages and storms, it spews out a continuous stream of plasma—a thin, electrically neutral spray of charged particles. A gusty, blustery outpouring of both matter and energy, this "solar wind" blasts through space at speeds of 1 million to 3 million kilometres per hour.

As it journeys out into the universe, the solar wind first sweeps past Mercury and Venus. Then, two or three days after leaving the sun, it approaches earth, threatening all life on our planet with a lethal bombardment. Fortunately, about three minutes (or 65 000 kilometres) out, the wind crashes into the earth's magnetic field and is deflected away from the surface of the planet. But the solar wind is not stopped by this collision. Instead it blows on past the earth and sweeps around the magnetic field. As it does this, it drags the field into a long tail that stretches far past the moon, to a distance of more than 6 million kilometres. All along this vast surface, the solar plasma is in direct contact with lines of magnetic force that originate near the north and south poles of the planet (see diagram on pages 116–17).

Like the earth, the sun is magnetic. As a result, the outflowing plasma that flows past the earth is imprinted with solar magnetic force. In the metaphoric language of plasma physics, we can say that lines of force from the sun's magnetic field are "frozen

OPPOSITE: *This delicate array of southern lights was photographed from the space shuttle* Discovery *in the spring of 1991. Auroras have also been detected on Jupiter and Uranus and are likely to occur on Neptune and Saturn.*
COURTESY OF NATIONAL
AERONAUTICS AND SPACE
ADMINISTRATION

not to scale

sun

in" to the solar wind. The auroral system is minutely sensitive to changes in this solar-wind magnetic field, which varies not only in strength but, even more significantly, in orientation.

All magnetic fields have a direction, the property to which a compass needle reacts. The magnetic fields emitted from the sun, formed in the chaos of the solar surface, are bent and distorted. When the sun's plasma is ejected into the solar wind, it carries these twisted fields into the universe. If the solar magnetism that grazes past the earth's magnetic tail happens to exert its force in one direction (which physicists call "northward"), the solar wind has little effect on the magnetosphere. But if the sun's magnetism points the other way ("southward"), a switch is instantly thrown and huge amounts of energy course through the auroral circuits.

It is still not clear how this power is produced, but many physicists believe that the first step is an actual merging of the solar and terrestrial magnetic fields. All along the surface of the magnetotail, lines of force from the solar wind and from the earth are thought to fuse with each other. As gusts of plasma blow across the fused lines, electrical power is generated. As Michael Faraday realized in the 1800s, electricity is produced whenever a good conductor—like the ionized solar wind—experiences a

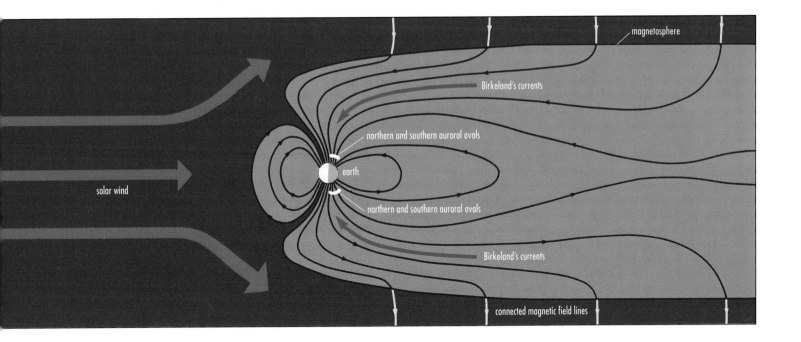

This diagram is a simplified representation of the sun-earth generator that powers the aurora.

Labels in diagram: magnetosphere; Birkeland's currents; northern and southern auroral ovals; earth; solar wind; northern and southern auroral ovals; Birkeland's currents; connected magnetic field lines

changing magnetic force—in this case by blowing across the connected magnetic fields. The solar-wind/magnetospheric generator puts out about 9 billion kilowatt hours of power a year, or ten times the annual power production of the United States.

In some way or other (again the details are obscure), all this power finds its way into the magnetotail. The tail is divided into north and south lobes, and equal-but-opposite surges of power flow through them both. Both protons and electrons flood along these routes, but the protons are, for our purposes, of little significance. What matters are the electrons. As these negatively charged particles move through the twinned channels of the magnetotail, they are ultimately led towards earth, following lines in the magnetic field that lead to the atmosphere of the polar regions. These floods of electrons, which link the magnetospheric dynamo with the ionosphere, are called field-aligned, or Birkeland, currents. Their symmetry accounts for the mirroring of northern and southern auroras.

As the Birkeland currents continue downward towards earth, their progress is as zestful and restless as the lights to which they will soon give birth. Cascading in broad sheets, they are shaped into eddies and curls, exactly analogous to those that form in turbulent water. Then, about 10 000 kilometres above ground, some of them tumble

FRED'S AURORAL NURSERY

The solar-terrestrial generator that powers the aurora pours out huge amounts of electrical energy. Could this energy ever be tapped and put to human use? Scientists think it highly unlikely. Auroral processes occur on too large a scale and at too great a distance for us to tame them. But science-fiction writers are not constrained by mere practicalities. As early as 1885, one of their number was harnessing the aurora to do useful work. In his book *The Voyage of the Vivian to the North Pole and Beyond*, T. W. Knox had his characters, George and Fred, speculate on the purposes to which the auroral energy could be put. As George saw it, auroral power would usher in the millennium:

> "We will make it run the dynamos to supply our houses and streets with electrical light; it shall propel our machinery, and thus take the place of steam; it shall be used for forcing our gardens, in the way that electricity is supposed to make plants grow; and it shall develop the brains of our statesmen and legislators, to make them wiser and better and of more practical use than they are at present. Hens shall lay more eggs, cows must give cream in place of milk, trees shall bear fruit of gold or silver, tear-drops shall be diamonds, and the rocks of the field shall become alabaster or amber. Wonderful things will be done when we get the electricity of the aurora under our control."

"Yes," responded Fred, "babies shall be taken from the nursery and reared on electricity, which will be far more nutritious than their ordinary food. When the world is filled with giants nourished from the aurora, the ordinary mortal will tremble. We'll think it over, and see what we can do."

Unable to do any of these things, scientists have nonetheless thought things over, too. The result has been the development of an electrical generator that works on the same principles as the natural auroral machine. Known as the MHD, or magnetohydrodynamic, generator, it is employed in both research and industry.

over the electromagnetic equivalent of a steep precipice, which shapes them into a narrow, curtainlike beam. At the same time, this formation provides the electrons with an extra jolt of power that causes them to accelerate. Only electrons that receive this boost are able to continue into the earth's atmosphere.

By now the currents have acquired almost all the major features of the aurora—speed, rippling movements, curtainlike forms, and symmetry around the north and south poles. The only problem is that they are invisible. This characteristic changes in an instant when the electrons hit the air, several hundred kilometres over our heads. Although the outer fringes of the ionosphere are empty by earthly standards, they are the most crowded places that the incoming electrons have ever encountered. Unlike the magnetosphere, which is a near-vacuum, the upper atmosphere is a thin soup of gas particles—mostly atomic oxygen and molecular nitrogen. When a high-speed electron runs into one of these particles—say, an atom of oxygen—the oxygen takes on some of the electron's energy and stores it in its subatomic circuits. We say that the oxygen has become "excited." If this atom then bumps into another atom or molecule, the extra energy is lost in the collision. But if the oxygen can store the energy for a split second, it will radiate off naturally as a tiny burst of soft, greenish light. When thousands of atoms go off together, the sky comes to life with dancing auroras.

Depending on the conditions, the aurora becomes visible at heights of 400 to 1000 kilometres above ground. (This forms the top margin of the auroral curtains.) As the electrons cascade deeper into the ionosphere, the same soft light shimmers down the sky for several hundred kilometres. But about 100 kilometres above the earth, the green light goes out. This happens because the air here is much thicker than it was in the outer atmosphere. At this height, atoms and molecules of gas are constantly bumping into each other. When an atom of oxygen becomes excited by an electron, it is almost certain to suffer a collision in less than a second. The energy is lost to the impact, and no light is given off.

At about the same time, the incoming electrons start to run out of steam. Most of them do not have enough energy to venture deeper into the atmosphere. But a few high-energy particles continue the journey, tunnelling down through denser and denser air, until they bottom out at a height of about 70 kilometres. Although the air is far too thick for the green-oxygen reaction to occur, the electrons can still get some action out of nitrogen. (Nitrogen also releases light higher up in the atmosphere, but it

GREAT RED AURORAS

Red auroras are very rare events. They occur only during major magnetic storms, when the ionosphere is hit by large numbers of high-energy particles. Under this bombardment, many electrons break loose from atoms and molecules in the atmosphere. These secondary electrons carry less energy than primary electrons from the magnetosphere. When an oxygen atom is excited by a secondary electron, the oxygen takes a small jolt of energy into its internal circuits. If atoms can contain this energy for a certain length of time, it will be given off as a flash of red light. When this reaction occurs on a large scale, the night sky is suffused with a lurid glow—the great red auroras that so alarmed our ancestors.

As such things go, the red-oxygen reaction is very slow. The atom must keeps its extra charge for almost two minutes before it begins to glow. Should it suffer a collision during this period, the light-producing reaction will be "quenched." Thus, red auroras only occur where the air is very thin—usually at heights above 200 kilometres.

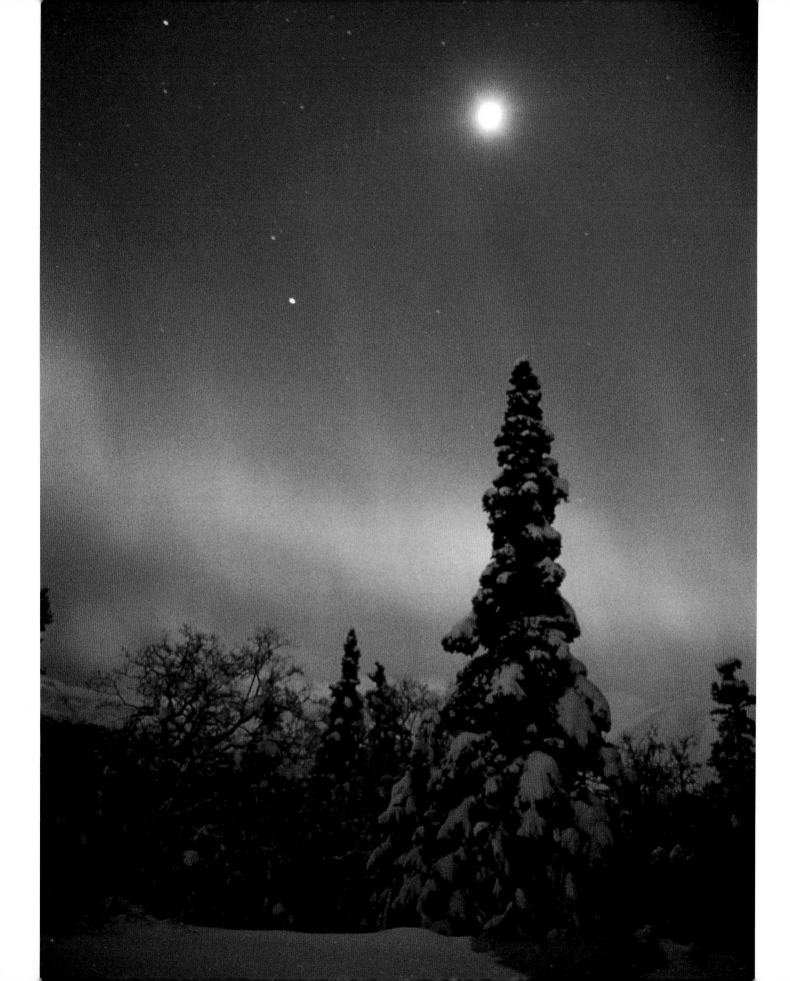

is a faint blue-violet colour that we don't see very well.) At the bottom of the aurora, nitrogen glows pink, producing the bright fringe that is seen on very active displays. Because the nitrogen molecules release light much faster than oxygen does, the fringes of the curtain seem to move more quickly than the green drapery above.

In the strictest sense, of course, the auroras themselves do not move, neither quickly nor slowly, regardless of their hue. The atoms and molecules that give off light are essentially still. It is the electron beams from the magnetosphere that run and ripple and swirl, like electric fingers that tickle the gases in the ionosphere. Or, to alter the metaphor, the sky is like a sensitive screen on which the invisible currents paint visible self-portraits. Every flicker gives us a clue about what is going on in the far darkness.

As we gaze up into the aurora with this whole picture in mind, it is sometimes possible to cast our minds into the outer distance of the solar wind and the magnetosphere—to imagine the plasma boiling away from the sun, the electrons raining down through space, the gases in the atmosphere tingling with light. When we do this, the aurora takes on a vast, vertical scale. But even so, we have not seen the lights in their full grandeur. For the aurora also has a horizontal dimension that is not immediately obvious to an earthbound observer.

When we scan the sky from a position on the ground, our view is restricted by our horizons. From farthest east to farthest west, our eyes can span a distance of about a thousand kilometres. On this scale, the aurora seems to consist of a few torn scraps of luminous drapery. But these fragments are actually part of a much larger phenomenon. Beyond our field of vision, the flickering bands of the aurora wave on and on, forming immense rings of wispy light that completely encircle the magnetic poles. Originally termed "auroral glories" because they resemble haloes, these luminous rings have become known by the disappointingly nondescript and inaccurate name of auroral ovals. (They are usually almost round.) At a minimum, the northern and southern ovals each extend around a circumference of about 13 000 kilometres, usually near 70 degrees of latitude north and south.

The auroral ovals are a constant feature of the upper atmosphere, year after year, hour after hour, both day and night. (We cannot ordinarily see daytime auroras because of the sunlight.) Maintaining a more or less steady position with reference to the sun, the aurora shines and plays while the earth turns under it. At any given time, some parts of the circle look peaceful—a soft, hazy bed of whitish light—while others go

"A WALL OF LIGHT"

Although a handful of scientists in the eighteenth and nineteenth centuries had played with the idea of large-scale auroral rings, no evidence of their existence was available until the International Geophysical Year (IGY)—a project so ambitious that it actually extended over fifteen months in the late 1950s. In a multinational effort that would have done Alexander von Humboldt proud, a co-ordinated network of 114 special "all-sky" cameras, set to take pictures at one-minute intervals, was trained on the aurora in both the Arctic and the Antarctic. In addition, hundreds of amateur and professional observers made hourly reports of auroras seen across North America. As information from individual witnesses was laid beside that from their neighbours, a magnificent, large-scale picture was pieced together. One night the IGY Auroral Data Center reported "a wall of light as long as the U.S. is wide, over 100 miles tall, with its bottom 60 miles from the ground, moving south at 700 miles per hour."

A few years later, in 1963, a Russian scientist named Yasha Feldstein worked with the IGY photographs to show that this towering wall of light likely encircled the globe. Although Feldstein's findings were pooh-poohed by many of his scientific colleagues, photographs taken from high-altitude jets and then from satellites soon proved that he was right.

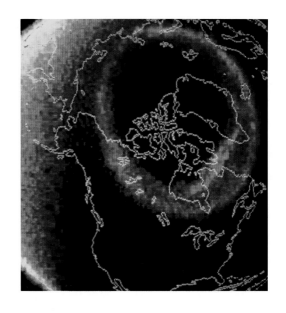

The entire northern auroral oval can be seen in this false-colour image from the Dynamics Explorer satellite. In this photograph, faint light shows as red, medium-bright light as orange, and bright light as yellow. The orange-yellow region on the left of the image is caused by the sun. Green lines have been added to show the position of North America. COURTESY OF L.A. FRANK, UNIVERSITY OF IOWA

wild with shimmering, shifting curtains. Together, these two related phenomena—"diffuse" (cloudlike) auroras and "discrete" (well-defined) forms—shape the contours of the auroral rings.

We are used to thinking of the aurora as capricious and wild—utterly and endlessly original. But in the past few years, it has become apparent that the behaviour of the auroral ovals is constrained within certain limits. Thus, while every brilliant aurora has its unique runs and riffs, these are best understood as free improvisations on a standard progression. That progression—the stages the aurora goes through as it develops and fades—is known to science as the auroral substorm.

Although substorms (like so much else) were first described by Kristian Birkeland, they were first documented in 1964 by Syun-Ichi Akasofu of the University of Alaska, using series of all-sky photographs and, later, imagery from spacecraft. For an observer on the ground, a typical substorm begins in the late evening hours with quiet auroral curtains that lie along the horizon. After a while, the lights brighten, and distinct streaks, or rays, appear in the glow. Soon a series of large, sweeping folds or spirals form, beginning near the eastern horizon and surging rapidly westward. This lovely spectacle is sometimes known as an auroral breakup, by analogy with the dramatic springtime release of ice from northern rivers.

The development of this westward-travelling surge marks the beginning of the so-called expansion phase of the substorm. It is followed, near midnight, by another outburst, in which the aurora suddenly brightens and then breaks into a wild fandango of swirling movement. After a few minutes of this, the scene gradually quiets down and the aurora resumes its demure appearance. This is the beginning of the recovery phase, in the early-morning hours, when the discrete forms disappear and are replaced by a vague, diffuse haze that resembles thin cloud. These clouds soon begin to flash on and off, in a display of power that is less spectacular than what has gone before, but no less awesome. From beginning to end, a substorm lasts from one to three hours. This process can be observed somewhere on earth at least once every twenty-four hours.

Scientists are still debating what it is that triggers these regular, patterned outbursts. Some believe that substorms are controlled by processes entirely within the magnetotail. According to this theory, the earth's magnetic field can be likened to a leaky bucket that is constantly taking in energy from the solar wind. Some of this energy leaks away in a continual drizzle of electrons that maintain the aurora in its quiet state. But as energy continues to pour in from the solar wind, the bucket goes on filling until,

SUBSTORMS FROM SPACE

Seen from space, a substorm is a convulsive spasm that affects the entire auroral system. A typical event begins in the portion of the oval farthest from the sun, at or near what is known as the midnight meridian. There the curtains suddenly flare with increased brilliance to mark the expansion phase. Within minutes this brightness spreads east and west around the nighttime hemisphere.

Meanwhile, back at the midnight location, the light has begun to rush northward, closing in on the hole at the centre of the ring. Eventually a large wave breaks out of this northerly flood and lunges to the west, forming the westward-travelling surge that ground-based observers may notice. Rounding the oval at 1 kilometre per second (or 3600 kilometres per hour), the surge moves out of the darkness and into the daytime portion of the aurora.

At the same time, other parts of the ring become calmer and the lights begin to fade, signalling the beginning of the pulsing recovery phase. Now, a few hours after the fireworks began, the nighttime half of the oval settles down in a gauzy haze.

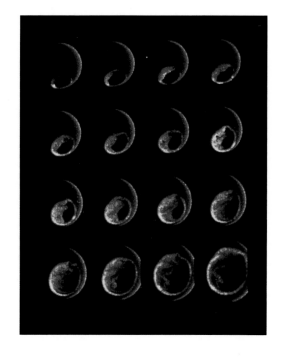

These images of the aurora were taken by cameras on the Dynamics Explorer satellite. They show the expansion and intensification of the aurora during a three-hour period, in response to incoming blasts of energy from the solar wind.

COURTESY OF L. A. FRANK, UNIVERSITY OF IOWA

THE HOLE IN THE DOUGHNUT

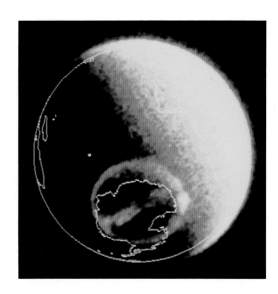

Polar-cap auroras dance across the auroral oval and over the earth's magnetic pole, as seen in this image from the Dynamics Explorer satellite. The green line has been added to indicate the position of Antarctica.

COURTESY OF L. A. FRANK,
UNIVERSITY OF IOWA

The hole in the centre of the auroral oval is called the polar cap. In the early twentieth century, Australian scientists working in Antarctica reported seeing auroras within this central zone. But nobody knew what to make of this fact, so it was largely ignored. Then in 1981 a photograph taken from the American satellite *Dynamics Explorer I* brought the subject to light again. It showed a thin auroral arc extending right across the cap, with connections at either end to the oval. This phenomenon was at first called a theta aurora because of its resemblance to the Greek letter theta, or Θ.

Since then, polar-cap auroras have been found to be both common and variable. At the auroral station at Eureka, in the Canadian high Arctic, auroras can be detected with sensitive cameras about half the time, though they are not always apparent to the human eye. When they are visible, they look like regular auroral draperies, only more active. They may be long or short and do not always (or even often) link with the oval. But they do show a constant allegiance to the sun, by pointing steadfastly in its direction. As the earth rotates beneath such a sun-aligned arc, the aurora seems to sweep round the sky like the hand of a clock. Why it does this is just one of many unanswered questions about the polar-cap aurora.

suddenly, it reaches its limit, overturns and floods its contents into the atmosphere. This massive influx of electrons and energy causes a substorm.

Others believe (with increasingly good evidence) that substorms are not just caused by changes within the magnetotail but are also triggered by the solar wind. To extend the metaphor, it is as if the magnetosphere's leaky bucket were held by a giant. When the giant is stung by a bee—in this case, a jab of energy from the solar wind—he loses his equilibrium and out spills the energy. To rephrase this description in more technical language, a substorm appears to be an impulsive, nonlinear response to subtle changes in the strength, polarity and angle of solar-wind magnetism.

Substorms are just one of the ways in which the aurora responds to the solar wind. As we have already seen, dramatic auroral displays tend to occur at intervals of 27 days, just the time it takes for the sun to rotate once, relative to the earth. This is because of features on the sun known as coronal holes—openings in the sun's magnetic field through which strong gusts of plasma shoot out. When one of these blasts nears the earth, the auroral machine goes on Red Alert. Extra energy surges into the magnetotail and through the auroral circuits, causing substorms to become more frequent, more active and more beautiful. At the same time, the auroral ovals expand towards the equator, bringing their splendour to audiences in more temperate latitudes. This may continue for several days and nights, until the coronal hole rotates away from us and sends its jet of plasma into empty space. On the next rotation, the blast hits us again; and then again and again, until the hole fades away.

The ability of the auroral ovals to change size—to expand and contract—is one of their most remarkable characteristics. They are like doughnut-shaped bubbles, quivering in the breeze, constantly teased and tickled by the changing winds of solar activity. When the solar wind is relatively quiet, the auroral bubbles hover placidly around the poles, experiencing brief orgasmic spasms when a substorm occurs. But when the wind is fierce, the ovals are rippled with storms as they swell and spread towards the equator. Any time auroras are seen at mid-latitudes, it is a sign the sun is hitting us with high-energy plasma. For example, the ovals tend to enlarge in the spring and fall because the earth is then seasonally tilted towards the outer margins of the sun—the regions where coronal holes are most likely to occur.

And what about sunspots? Do sunspots also enhance the flow of the solar wind? Is that why their numbers correlate, more or less, with reports of dramatic auroras? The

TOP: *A cluster of sunspots (dark areas) is surrounded by the fiery, magnetized tumult of the solar surface.* BOTTOM: *Flares, prominences and other dramatic events on the sun send sudden gales of plasma hurtling towards earth, where they may trigger magnetic storms and spectacular auroral outbursts.* BIG BEAR SOLAR OBSERVATORY, CALIFORNIA INSTITUTE OF TECHNOLOGY

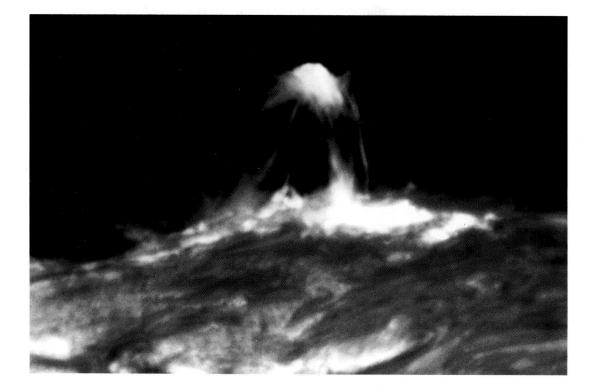

present-day answer is (as you might expect) intriguingly convoluted. In the first place, it turns out that sunspots are not themselves sources of solar wind. Instead, they are areas of intense magnetism that actually hold the plasma in. But even though sunspots do not release solar wind, they are associated with other structures that do. Both result from chaotic movements in the core of the sun, which work up to peak intensity about once in eleven years. When the core builds to full boil, sunspots become larger and more numerous, and the magnetic fields within them get twisted and stretched. They are like powerful, tightly wound springs, stressed to the breaking point. Sooner or later, the tension explodes in a fiery prominence, or solar flare, which usually erupts in the region near a large group of spots. As the explosion belches forth tongues of fire, it hurtles gale-force plasma into the solar system.

When this hurricane hits the earth's field a few days later, electrical power charges through the auroral circuits. As the auroral ovals receive this surge, they overflow their usual bounds and flood both south and north towards the equator. Strong substorms hit one after the other, filling the skies with their brilliant theatrics. Under exceptional circumstances, high red-oxygen aurora may also develop at these times and wrap the globe in a blaze of crimson.

And so you have it, at least in broad outline—the space-age understanding of the polar lights. While some aspects of the process remain obscure (the exact nature of the solar-wind/earth dynamo, the structure of the electron accelerator above the auroral curtains, the physics of a substorm), the basic picture is beyond dispute. We have been up there with our cameras and instruments. We have collected "ocular proof" to support our theories. Whatever revisions the future may judge necessary, we know that many age-old questions have received answers.

But at the same time we know that our questions about the aurora can never be put to rest. The aurora is not just a puzzle to solve; it is also a mystery to experience. We cannot account for the miracle of a leaf through biochemistry nor explain a human child through developmental theory. Why should we expect to still the aurora with physics and mathematics? For even if we could account, minute by minute, for every fold and flicker of light, we would not have it all. We would know *how* the aurora is formed, but nothing can tell us *why*. Why has our home planet, earth, been graced with this glory? And why have our minds always been tuned to watch it in awe?

THE "WIRED-IN" UNIVERSE

OPPOSITE: *Like a delicate cosmic flower, this auroral corona seems to draw us into the heavens.*

R. SAMPSON

An active aurora always causes magnetic disturbances—fluctuations in the earth's magnetic field that can be felt by sensitive instruments. Most of the time these effects are confined to the Arctic and Antarctic, in the zones where the aurora shines. Such local perturbations are caused by strong electric currents—the eastward and westward auroral electrojets—that flow through the ionosphere, about 100 kilometres up, near the bottom edge of the auroral curtains. Most intense during auroral substorms, these currents send shivers through the earth's magnetic field that are detected as magnetic substorms.

Magnetic substorms last for a few hours. Full-fledged magnetic storms are much larger disturbances that last for several days and typically include a number of substorms. They occur when the earth is struck by a blast of solar wind from a flare or coronal hole. In these cases the magnetic fluctuations are caused by a large ring current that flows around the earth. When the solar wind is relatively placid, the ring current is weak and its magnetic effects are correspondingly small. But when the solar wind is strong, the ring current intensifies. All over the earth, compasses and magnetometers register magnetic tremors induced by the near-space current.

Both magnetic storms and substorms can interfere with human technology. For example, the auroral electrojets often disrupt high-frequency radio links. Ordinarily, radio waves are broadcast from a transmitter and are propagated upward to the ionosphere. The ionosphere then reflects them back to earth, where they are picked up by receivers. But when the ionosphere is disrupted by strong auroral currents, it does not act as a reliable mirror. Messages become broken, garbled, hissy and inaudible. This is most likely to occur at high latitudes, exactly where radio communication is most critical.

Strong magnetic disturbances also cause problems with industrial installations in the Arctic—pipelines, for example, and power plants. The fluctuating magnetic fields cause electrical currents to flow through pipes, transmission wires and other conductors, leading to corrosion and equipment failure. A magnetic storm on 13 March 1989 knocked out Hydro Quebec's power system for about nine hours, leaving six million people in darkness.

But the force of magnetic storms may also affect us much more directly. Some scientists believe that living cells are acutely sensitive to the earth's magnetic field. According to research by Robert O. Becker, Frank A. Brown, A. A. Marino and others, delicate magnetic fluctuations may affect such basic biological functions as metabolic rates, immune response, orientation systems and sleep-and-wake cycles. If this is true, then the living world is "wired in" to the auroral circuits. Thus for us, as for the traditional peoples of the polar zones, the aurora hints at a dynamic link between ourselves and the cosmos beyond.

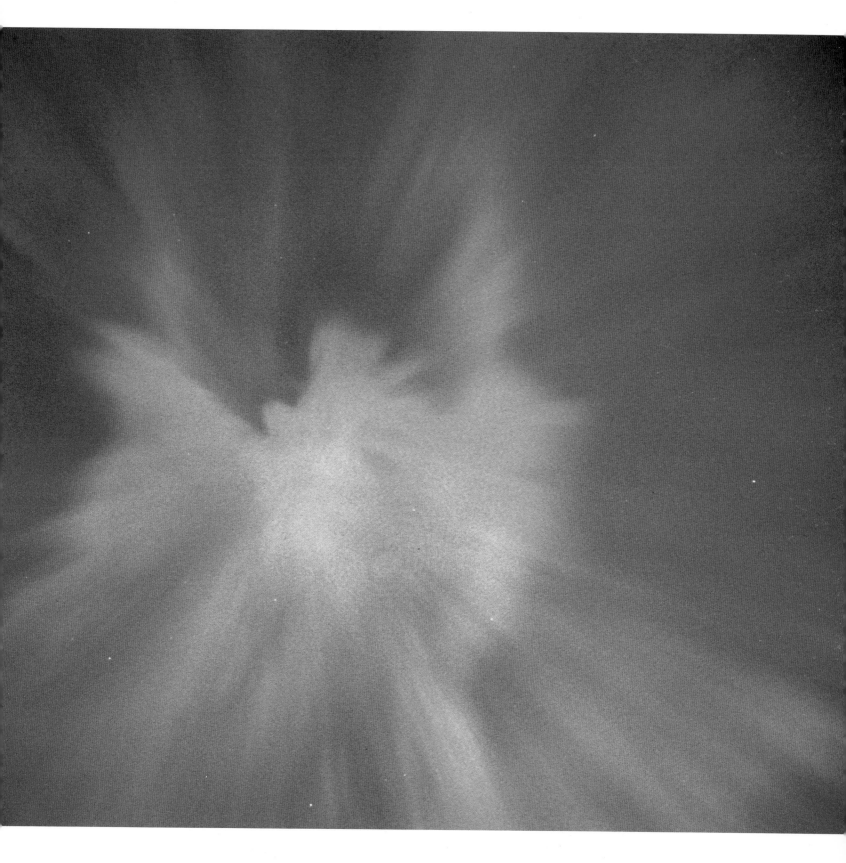

Notes refer to direct quotations only. For a complete listing of sources, please consult the references.

CHAPTER 1

Page 13, Albert Einstein, "Autobiographical Notes," as quoted by Timothy Ferris, *Coming of Age in the Milky Way* (New York: Doubleday, 1988), p. 185.

CHAPTER 2

Page 25, Inuit drum song from Charles Hofmann, *Drum Dance: Legends, ceremonies, dances and songs of the Eskimos* (Agincourt: Gage, 1974), p. 43.

Sir Walter Scott, "The Lay of the Last Minstrel," as quoted by Robert H. Eather, *Majestic Lights: the aurora in science, history and the arts* (Washington, D.C.: American Geophysical Union, 1980), p. 103.

Page 26, Aldo Massola, *Bunjil's Cave: myths, legends and superstitions of the Aborigines of south-east Australia* (Melbourne: Lansdowne Press, 1968), p. 162.

Page 28, Finnish and Swedish sayings from A. Brekke and A. Egeland, *The Northern Light: from mythology to space research* (Berlin: Springer-Verlag, 1983), p. 1; and Haavio, Martti, "Volkstümliche Auffassungen vom

NOTES

Nordlicht," *Sitzungsberichten der Finniscian Akademie der Wissenschaften* (1944), p. 5.

Chinese record from the *Chu-Shu-Chi-Nien*, as quoted by Robert H. Eather, *Majestic Lights*, p. 40.

Swedish tradition from Brekke and Egeland, *The Northern Light*, p. 15.

Knud Rasmussen, *Intellectual Culture of the Copper Eskimos* (Copenhagen: Report of the Fifth Thule Expedition 1921-24, 1932), p. 23.

Page 30, Howard Friedman and Robert O. Becker, "Geomagnetic Parameters and Psychiatric Hospital Admissions," *Nature* 200 (1963), pp. 626-28.

Page 31, Report of heart treatment, Dorothy Jean Ray, "Legends of the Northern Lights," *Alaska Sportsman* (April 1958), p. 39.

Page 31f, John Blunt Horn, as recorded by James R. Walker, *Lakota Belief and Ritual* (Lincoln: University of Nebraska Press, 1980), pp. 203-4.

Page 33, Uno Holmberg, "Finno-Ugric," *The Mythology of All Races*, vol. 4 (New York: Cooper Square, 1964), p. 77.

Hervarar Saga, as quoted by Hilda Roderick Ellis, *The Road to Hel: a study of the conception of the dead in Old Norse literature* (Cambridge: Cambridge University Press, 1943), p. 175.

Page 37, Pliny the Elder, as quoted by Eather, *Majestic Lights*, p. 38.

Page 38, Alfred Angot, *The Aurora Borealis* (New York: Appleton, 1896), pp. 6-7.

Our Lady of Fatima from W. C. McGrath, *Fatima or World Suicide*, as quoted by Eather, *Majestic Lights*, p. 106.

Norwegian chant, as quoted by Brekke and Egeland, *The Northern Light*, p. 4.

Page 40, Catherine Mitchell, interview with the author, Dene Cultural Institute, Yellowknife, N.W.T., 1990.

Page 42, Gwich'in text from *The Book of Dene: containing the traditions and beliefs of Chipewyan, Dogrib, Slavey, and Loucheux peoples* (Programme Development Division, N.W.T. Department of Education, no date), p. 61.

CHAPTER 3

Page 45, Aristotle, *Meteorologica*, translated by H. D. P. Lee (London: Heinemann, 1963), p. 13.

Ezekiel's vision from *Ezekiel* I: 1-28 passim.

Anaximenes, as quoted by Eather, *Majestic Lights*, p. 35.

Page 47, Carl Sagan from Carl Sagan and Ann Druyan, *Comet* (New York: Pocket Books, 1985), p. 23.

Page 47f, Aristotle, *On the Heavens*, as quoted by Timothy Ferris, *Coming of Age in the Milky Way*, p. 69.

Page 48, Timothy Ferris, *Coming of Age in the Milky Way*, p. 69.

Page 50, *The King's Mirror*, as quoted in Brekke and Egeland, *The Northern Light*, p. 37.

Page 52, Galileo, "Discourse on the Comets," which appeared under the name of Galileo's associate Mario Guiducci in 1619. In Stillman Drake and C.D. O'Malley, *The Controversy on the Comets of 1618* (Philadelphia: University of Philadelphia Press, 1960), pp. 53-54.

Page 52f Descartes, *Les Météores*, in his Oeuvres, vol. V (Paris: F. G. Levrault, 1824), pp. 157, 263-64.

Page 53, Alexander von Humboldt, *Cosmos: a sketch of a physical description of the universe* (New York: Harper, 1860), vol. 1, p. 199.

Page 54, Samuel von Triewald from a paper presented to the Royal Swedish Academy of Science and Letters, as quoted by Brekke and Egeland, *The Northern Light*, p. 64.

Page 54ff, Halley, in 1716, from *Philosophical Transactions of the Royal Society of London* 29, passim. Passage on concentric globes from a paper dated 1692, from *Philosophical Transactions of the Royal Society of London* 16, p. 575.

Page 59, Hiorter from a paper to the Royal Swedish Academy of Science, 1747, as quoted by Eather, *Majestic Lights*, p. 70, and Brekke and Egeland, *The Northern Light*, p. 62.

Page 60, Wilcke from a paper to the Royal Swedish Academy of Science, 1777, as quoted by Brekke and Egeland, *The Northern Light*, pp. 71-72.

 Dalton from *Meteorological Observations and Essays*, 1793, and other writings, as quoted by Eather, *Majestic Lights*, pp. 60-62.

 de Mairan, *Traité physique et historique de l'aurore boréale* (Paris: L'imprimerie royale, 1754), p. 264.

Page 62, Didrich Christian Fester, as quoted by Brekke and Egeland, *The Northern Light*, p. 72.

 de Mairan, as quoted by Eather, *Majestic Lights*, p. 55.

 Epigram on Franklin from the French economist Turgot, as quoted in the biography of Franklin in the *Encyclopædia Britannica*.

 Carl van Doren, *Benjamin Franklin* (New York: Viking, 1966), p. 632.

Page 63, Franklin's paper on the aurora from *Political, Miscellaneous and Philosophical Pieces*, 1779, as quoted by Eather, *Majestic Lights*, p. ix.

Page 64, Lomonosov, as quoted by Eather, *Majestic Lights*, p. 70.

 de Mairan, *Traité*, p. 445.

 Newton from his rules for Biblical interpretation, as quoted by John Hedley Brooke, *Science and Religion: some historical perspectives* (Cambridge: Cambridge University Press, 1991), p. 149.

CHAPTER 4

Page 69, James Clerk Maxwell, as quoted by C. W. F. Everitt, *Dictionary of Scientific Biography*, vol. ix, p. 227.

 French writer M Haüy, *Natural Philosophy*, 1807, as quoted by Eather, *Majestic Lights*, p. 63.

 Humboldt re trumpet, as quoted by Kellner, *Alexander von Humboldt* (London: Oxford University Press, 1963), p. 1.

 Charles Darwin, letter to J. Hooker, 10 February 1845, as quoted by Kellner, *Alexander von Humboldt*, p. 34.

Page 69f, Humboldt re tools, *Personal Narrative*, as quoted by Susan Faye Cannon, *Science in Culture: the early Victorian period* (New York: Science History Publications, 1978), p. 76.

Page 72, Humboldt re columns of flame, *Cosmos*, vol. 1, pp. 196, 191.

 Humboldt re network of stations, *Cosmos*, vol. 1, p. 191.

Page 73, Humboldt re observations, *Personal Narrative*, as quoted by Cannon, *Science in Culture*, p. 95.

 Humboldt re earnest endeavour, *Cosmos*, vol. 1, p. vii.

Page 76, Captain James Cook, as quoted by I. L. Thomsen, "The Aurora Australis," *The Antarctic Today: a mid-century survey by the New Zealand Antarctic Society*, ed. Frank A. Simpson (Wellington: A. H. and A. W. Reed, 1952), p. 161.

 John Biscoe, as quoted by I. L. Thomsen, "The Aurora Australis," *The Antarctic Today*, p. 262.

Page 77, J., "Lines Suggested by the Brilliant Aurora, Jan. 15, 1820," *The North Georgia Gazette and Winter Chronicle*, ed. Edward Sabine (London: John Murray, 1821), pp. 82-83. Attributed to Ross by Eather, *Majestic Lights*, p. 198.

Adolf E. Nordenskiold, *The Voyage of the Vega round Asia and Europe* (London: Macmillan, 1883), p. 36.

Page 78, Comment re motivation of explorers from the commission of Abel Tasman, 1642, as quoted by Daniel J. Boorstin, *The Discoverers* (New York: Vintage, 1983), p. 279.

Charles Francis Hall, *Life with the Esquimaux: a narrative of Arctic experience in search of survivors of Sir John Franklin's expedition* (London: Sampson Low, Son, and Marston, 1865), pp. 127-28.

Fridtjof Nansen, *Farthest North: the Norwegian polar expedition*, 1893-1896, vol. 1 (Westminster: Archibald Constable, 1897), p. 221.

Page 79, Robert F. Scott from his journals, as quoted by Eather, *Majestic Lights*, p. 145.

Page 81, Humboldt, *Cosmos*, vol. 1, p. 192.

Comment about Schwabe from Manuel J. Johnson, "An Address delivered at the Annual General Meeting of the Royal Astronomical Society, February 13, 1857," *Memoirs of the Royal Astronomical Society* 26 (1858): 200.

Sabine, as quoted in Sydney Chapman, *Geomagnetism* (Oxford: Clarendon Press, 1962), p. 935.

Page 82, Richard Carrington, "Descriptions of a Singular Appearance Seen in the Sun on September 1, 1859," *Monthly Notices of the Royal Astronomical Society* 20 (1860), pp. 13-15.

Page 87, Helena Petrovna Blavatsky, *The Secret Doctrine* (Adyar, India: Theosophical Publishing House, 1888, 1978), pp. 633-34.

CHAPTER 5

Page 93, Albert Einstein, as quoted by Daniel J. Boorstin, *The Discoverers* (New York: Vintage, 1983), p. 625.

Olaf Devik re Birkeland in classroom, *Amidst Fishermen, Physicists, and Other People*, as quoted by Brekke and Egeland, *The Northern Light*, p. 101.

Kristian Birkeland re electromagnetic gun, as quoted by Brekke and Egeland, *The Northern Light*, p. 101.

Page 94, Kristian Birkeland, *The Norwegian Aurora Polaris Expedition*, 1902-1903. vol. 1 (Christiania: H. Aschehoug, 1908), pp. 8, 9.

Page 98, Physicist Arthur Schuster, *The Progress of Physics* (New York: Arno Press, 1975 [1911]), p. 59.

Lord Kelvin, 1892, as quoted by A. J. Dessler, "Solar Wind and the Interplanetary Magnetic Field," *Reviews of Geophysics* 5 (1967), p. 2.

Samuel Pierpoint Langley, 1889, as quoted by A. J. Dessler, "The Evolution of Arguments Regarding the Existence of Field-aligned Currents," *Magnetospheric Currents*, ed. Thomas A. Potemra (Washington, D.C.: American Geophysical Union, 1984), p. 22.

Page 99, Carl Störmer, as quoted by Sydney Chapman, "Fredrik Carl Mülertz Störmer, 1874-1957," *Royal Society of London, Biographical Memoirs* 4 (1958), p. 274.

Page 101, Robert W. Service, "The Ballad of the Northern Lights," *Ballads of a Cheechako* (Toronto: William Briggs, 1909), pp. 27–28.

Page 107, A. J. Dessler on Alfvén and Chapman, "The Evolution of Arguments Regarding the Existence of Field-aligned Currents," *Magnetospheric Currents*, p. 25.

Page 109, Walter A. McDougall, . . . *the Heavens and the Earth: a political history of the space age* (New York: Basic Books, 1985), p. 44.

James A. van Allen, *The Origins of Magnetospheric Physics* (Washington, D.C.: Smithsonian, 1983), p. 47.

CHAPTER 6

Page 115, W. N. Abbott, *Sydney Chapman, Eighty from his Friends*, ed. Syun-Ichi Akasofu et al. (Privately published, 1968), p. 66.

Walt Whitman, as quoted in *Audubon's Birds* (Philadelphia: Running Press, 1992).

Page 118, T. W. Knox, *The Voyage of the Vivian to the North Pole and Beyond*, as quoted by Eather, *Majestic Lights*, p. 242.

Page 123, Carl Gartlein, head of the IGY Auroral Data Center, as quoted by Eather, *Majestic Lights*, p. 175.

GENERAL

Akasofu, S.-I. 1979. *Aurora Borealis: the amazing northern lights*. Anchorage: Alaska Geographic.
Brekke, A., and Egeland, A. 1983. *The Northern Light: from mythology to space research*. Berlin: Springer-Verlag.
Davis, Neil. 1992. *The Aurora Watcher's Handbook*. Fairbanks: University of Alaska Press.
Eather, Robert H. 1980. *Majestic Lights: the aurora in science, history and the arts*. Washington, D.C.: American Geophysical Union.

CHAPTER 2

Suzanne Niviattian Aqatsiaq was interviewed by Louis Tapardjuk at the Science Institute of the Northwest Territories, Igloolik, N.W.T., in January 1990. Catherine Mitchell and Alexis Arrowmaker were interviewed by the author at an elders' conference of the Dene Cultural Institute in 1990.
Aarne, Antti. 1918. *Estnische Märchen -und Sagenvariaten*. FF Communications No. 25.
Alexander, H. B. *The Mythology of All Races: North American*, vol. x. New York: Cooper Square.
Bell, James Mackintosh. 1903. The fireside stories of the Chippwyans, *Journal of American Folklore* 16: 73–84.

REFERENCES

Birket-Smith, Kaj, and de Laguna, Frederica. 1938. *The Eyak Indians of the Copper River Delta, Alaska*. Copenhagen: Levin and Munksgaard.
Boas, Franz. 1901. The Eskimo of Baffin Land and Hudson Bay, *Bulletin of the American Museum of Natural History* 15.
Bogoras, W. 1909. The Chukchee, *Memoirs of the American Museum of Natural History* 21: 333–35.
The Book of Dene: containing the traditions and beliefs of Chipewyan, Dogrib, Slavey, and Loucheux peoples. No date. Yellowknife, N.W.T.: Programme Development Division, N.W.T. Department of Education.
Brekke, A., and Egeland, A. 1980. Det historiske nordlys. *Ottar* 121–22.
Brown, Emily Ivanoff. 1987. *Tales of Ticasuk: Eskimo legends and stories*. Fairbanks: University of Alaska Press.
Brown, Mrs. W. Wallace. 1890. Wa-ba-ba-nal, or northern lights. *Journal of American Folklore* 3: 213–14.
Canfield, William W. 1971 (1902). *The Legends of the Iroquois: told by "the Cornplanter."* Port Washington: Friedman.
Cannon, Anthony S. 1984. *Popular Beliefs and Superstitions from Utah*. Salt Lake City: University of Utah Press.
Coxwell, C. Fillingham. 1983 (1925). *Siberian and Other Folk-Tales*. New York: AMS Press.
Creighton, Helen. 1968. *Bluenose Magic: popular beliefs and superstitions in Nova Scotia*. Toronto: Ryerson.
Duncan-Kemp, A. M. 1952a. *Where Strange Paths Go Down*. Brisbane: W. R. Smith and Paterson Pty.
———. 1952b. Queensland aboriginal lore, *Mankind* 4 (9): 382–88.
Ellanna, Frank, et al. 1988. *Ugiuvangmiut Quliapyuit: King Island Tales, Eskimo history and legends from Bering Strait*. Alaska Native Language Center and University of Alaska Press.
Ellis, Hilda Roderick. 1943. *The Road to Hel: a study of the conception of the dead in Old Norse literature*. Cambridge University Press.
Falck-Ytter, Harald. 1983. *Aurora: the northern lights in mythology, history and science*. Edinburgh: Floris Books.
Fréchette, Louis. 1977. *Contes II: masques et fantômes et les autres contes épars*. Montreal: Fides.
Friedman, Howard, and Becker, Robert O. 1963. Geomagnetic parameters and psychiatric hospital admissions. *Nature* 200: 626–28.
Gregory, J. W. 1907. *Australasia*, vol. 1. London: Edward Stanford.
Gromnica, Eva. 1971. An unbelievable story about northern lights. *North/Nord* 18(4): 44–46.
Gubser, Nicholas J. 1965. *The Nunamiut Eskimos: hunters of caribou*. New Haven: Yale University Press.
Haavio, Martti. 1944. Volkstümliche Auffassungen vom Nordlicht. *Sitzungsberichten der Finniscian Akademie der Wissenschaften*, Helsinki.
Hamilton, James Cleland. 1903. The Algonquin Manabozho and Hiawatha. *Journal of American Folklore* 16: 229–33.

Hand, Wayland D., et al. 1981. *Popular Beliefs and Superstitions: a compendium of American Folklore*, 3 vol. Boston: G. K. Hall.

Hand, Wayland D., ed. 1964. *Popular Beliefs and Superstitions from North Carolina*. Durham: Duke University Press.

Hearne, Samuel. 1958. *A Journey from Prince of Wales's Fort in Hudson's Bay to the Northern Ocean 1769, 1770, 1771, 1772*. Toronto: Macmillan.

Hewitt, J. N. B. 1974 (1899–1900). *Iroquoian Cosmology, first part*. New York: AMS Press.

Hoffman, Walter James. 1970 (1896). *The Menomini Indians*. New York: Johnson Reprint Corporation.

Hofmann, Charles. 1974. *Drum Dance: legends, ceremonies, dances and songs of the Eskimos*. Agincourt: Gage.

Holmberg, Uno. 1964. *The Mythology of All Races: Finno-Ugric, Siberian*, vol. 4. New York: Cooper Square.

Holzworth, Robert H., II. 1975. Folklore and the aurora. *Eos* 56: 686–88.

Jones, William. 1911–12. Notes on the Fox Indians. *Journal of American Folklore* 24: 209–37.

König, Herbert L., et al. 1981. *Biologic Effects of Environmental Electromagnetism*. New York: Springer-Verlag.

Lemieux, Germain. 1975. *Les vieux m'on' conté*. Montreal: Les Editions Bellarmin.

McClintock, Walter. 1923. *Old Indian Trails*. Boston: Houghton Mifflin.

Mackenzie, Donald A. 1935. *Scottish Folk-lore and Folk Life: studies in race, culture and tradition*. London: Blackie and Son.

MacMillan, Cyrus. 1974. The northern lights, *Canadian Wonder Tales*. London: Bodley Head.

Massola, Aldo. 1968. *Bunjil's Cave: myths, legends and superstitions of the Aborigines of south-east Australia*. Melbourne: Lansdowne Press.

Merkur, Daniel. 1985. *Becoming Half-Hidden: shamanism and initiation among the Inuit*. Stockholm: Almquist and Niksell International.

Millman, Lawrence. 1987. *A Kayak Full of Ghosts*. Santa Barbara: Capra.

Nansen, Fridtjof. 1893. *Eskimo Life*. London: Longmans, Green.

Norman, Howard. 1990. *Northern Tales: traditional stories of Eskimo and Indian peoples*. New York: Pantheon.

Petrie, William. 1963. *Keoeeit: the story of the aurora borealis*. London: Pergamon.

Pulu, Tupou L., and Pope, Mary L. 1981. *Beliefs from Nikolai*. Anchorage: National Bilingual Materials Development Center, University of Alaska.

Radford, E. and M. A. 1969. *Encyclopedia of Superstitions*. London: Hutchinson.

Rasmussen, Knud. 1932. *Intellectual Culture of the Copper Eskimos*. Copenhagen: Report of the Fifth Thule Expedition 1921–24.

———. 1929. *Intellectual Culture of the Iglulik Eskimos*. Copenhagen: Report of the Fifth Thule Expedition 1921–24.

———. 1908. *The People of the Polar North: a record*. London: Kegan Paul, Trench, Trubner.

Ray, Dorothy Jean. 1958. Legends of the northern lights. *Alaska Sportsman* (April): 20–21, 36–39.

Reed, A. W. 1974. *An Illustrated Encyclopedia of Maori Life*. Wellington: A. H. and A. W. Reed.

———. 1946. *Myths and Legends of Maoriland*. Wellington: A. H. and A. W. Reed.

Rink, Henrik. 1974. *Tales and Traditions of the Eskimo*. Montreal: McGill-Queen's University Press.

Spencer, Robert F. 1969. The North Alaskan Eskimo: a study in ecology and society. *Smithsonian Institution Bureau of American Ethnology Bulletin* 171.

Stadler, Valerie. 1972. *Legends and Folktales of Lappland*. London: Mowbrays.

Story, G. M., et al. 1982. *Dictionary of Newfoundland English*. Toronto: University of Toronto Press.

Swan, James G. 1869. The Indians of Cape Flattery. *Smithsonian Contributions to Knowledge* No. 220.

Turi, Johan, and Turi, Per. 1918–19. *Lappish Texts*. Copenhagen: Andr. Fred. Host and Son.

Turner, Lucien M. 1979. *Ethnology of the Ungava District, Hudson Bay Territory*. Québec: Presse Coméditex.

Walker, James R. 1980. Lakota Belief and Ritual. Lincoln: University of Nebraska Press.

———. 1917. The Sun Dance and other ceremonies of the Oglala division of the Teton Dakota. *Anthropological Papers of the American Museum of Natural History* 16, pt. 2.

West, Eric. 1991. *Catch ahold this one. . . : songs of Newfoundland and Labrador*, vol 1. St. John's: Vinland Music.

Weyer, Edward Moffat. 1969. *The Eskimos: their environment and folkways*. Hamden, Conn.: Archon Books.

CHAPTER 3

In addition to the sources listed below, this chapter is based on biographies of Anaxagoras, Anaximenes, Aristotle, Tycho Brahe, Anders Celsius, John Dalton, René Descartes, Leonhard Euler, Benjamin Franklin, Galileo Galilei, William Gilbert, Edmond Halley and Mikhail Lomonosov from the *Encyclopædia Britannica* and the *Dictionary of Scientific Biography*.

Allen, Reginald E. 1966. *Greek Philosophy: Thales to Aristotle*. Toronto: Collier-Macmillan.

Aristotle. 1963. [ca. 345 B.C.] *Meteorologica*. Translated by H. D. P. Lee. London: William Heinemann.

Armitage, Angus. 1966. *Edmond Halley*. London: Nelson.

Berman, Morris. 1981. *The Reenchantment of the World*. Ithaca: Cornell University Press.

Bicknell, P. J. 1968. Did Anaxagoras observe a sunspot in 467 B.C.? *Isis* 59: 87–90.

Briggs, J. Morton, Jr. 1967. Aurora and enlightenment: eighteenth-century explanations of the aurora borealis. *Isis* 58: 491–503.

Brooke, John Hedley. 1991. *Science and Religion: some historical perspectives*. Cambridge: Cambridge University Press.

Canton, John. 1753. Electrical experiments, with an Attempt to account for their several Phaenomena; together with some Observations on Thunder-Clouds, *Philosophical Transactions of the Royal Society of London* 48: 350–58.

Chapman, Sydney. 1967. History of aurora and airglow. *Aurora and Airglow*, edited by Billy M. McCormac. New York: Reinhold.

———. 1943. Edmond Halley and geomagnetism. *Terrestrial Magnetism and Atmospheric Electricity* 48: 131–44.

Davis, C.H., ed. 1876. *Narrative of the North Polar Expedition*. Washington, D.C.: U.S. Naval Observatory.

de Mairan, Jean Jacques d'Ortous. 1733, 1754. *Traité physique et historique de l'aurore boréale*. Paris: L'Imprimerie royale.

Descartes, R. 1824 [1638] *Les météores*. Oeuvres, vol. v. Paris: F. G. Levrault.

Dicks, D. R. 1970. *Early Greek Astronomy to Aristotle*. London: Thames and Hudson.

di Santillana, Giorgio. 1962 [1955]. *The Crime of Galileo*. New York: Time.

Drake, Stillman, and O'Malley, C. D. 1960. *The Controversy on the Comets of 1618*. Philadelphia: University of Philadelphia Press.

Eddy, John A. 1976. The Maunder minimum. *Science* 192: 1189–1202.

Ferris, Timothy. 1988. *Coming of Age in the Milky Way*. New York: Doubleday.

Hale, Edward E., and Hale, Edward E. Jr. 1887. *Franklin in France*. Boston: Roberts Brothers.

Halley, Edmund. 1719. An Account of the Phaenomena of a very extraordinary Aurora Borealis, seen at London on November 10. 1719. both Morning and Evening. *Philosophical Transactions of the Royal Society of London* 30: 1099–1100.

———. 1716. An account of the late surprising Appearance of the Lights seen in the Air, on the sixth of March last; with an Attempt to explain the Principal Phaenomena thereof. *Philosophical Transactions of the Royal Society of London* 29: 406–28.

———. 1692. An Account of the cause of the Change of the Variation of the Magnetical Needle; with an Hypothesis of the Structure of the Internal parts of the Earth. *Philosophical Transactions of the Royal Society of London* 16: 563–78.

Jaki, Stanley. 1966. *The Relevance of Physics*. Chicago: University of Chicago Press.

Lindroth, Sten. 1952. *Swedish Men of Science* 1650–1950. Stockholm: The Swedish Institute.

Link, Frantisek. 1967. On the history of the aurora borealis. *Vistas in Astronomy*, vol. 9, edited by B. A. Beer. Oxford: Pergamon Press.

Mitchell, A. Crichton. 1932, 1937, 1939. Chapters in the history of terrestrial magnetism. *Terrestrial Magnetism and Atmospheric Electricity* 37: 105–46; 42: 241–80; 44: 77–80.

Sagan, Carl, and Druyan, Ann. 1985. *Comet*. New York: Pocket Books.

Silverman, S. M. 1970. Franklin's theory of the aurora. *Journal of the Franklin Institute* 290: 177–78.

Silverman, S. M., and Tuan, T. F. 1973. Auroral audibility. *Advances in Geophysics* 16: 155–266.

Siscoe, George L. 1978. An historical footnote on the origin of "aurora borealis." *Eos* 59: 994–97.

Stothers, Richard. 1979. Ancient auroras. *Isis* 70: 85–95.

Thrower, Norman J. 1981. *The Three Voyages of Edmond Halley in the* Paramore *1698–1701*. London: Hakluyt Society.

van Doren, Carl. 1966. *Benjamin Franklin*. New York: Viking.

CHAPTER 4

In addition to the sources listed below, this chapter is based on biographies of Anders Ångström, Svante Arrhenius, Henri Becquerel, Richard Carrington, James Cook, Michael Faraday, Georg Forster, Carl Gauss, Christopher Hansteen, John Herschel, Alexander von Humboldt, Elias Loomis, Edward Maunder, James Clerk Maxwell, Hans Christian Oersted, Edward Sabine, Samuel Schwabe, Balfour Stewart, J. J. Thomson and Wilhelm Weber from the *Encyclopædia Britannica* and the *Dictionary of Scientific Biography*.

Angot, Alfred. 1896. *The Aurora Borealis*. London: Kegan Paul, Trench, Trübner.

Bellot, J.-R. 1880. *Voyage aux mers polaires*. Paris: Garnier Frères.

Birkeland, Kr. 1908. *The Norwegian Aurora Polaris Expedition, 1902–1903*, vol 1. Christiania: H. Aschehoug.

Blavatsky, Helena Petrovna. 1978 [1888] *The Secret Doctrine*. Adyar, India: Theosophical Publishing House.

Boorstin, Daniel J. 1983. *The Discoverers*. New York: Vintage.

Brann, E. R. 1954. *Alexander von Humboldt: patron of science*. Madison: Littel.

Cannon, Susan Faye. 1978. *Science in Culture: the early Victorian period*. New York: Science History Publications.

Carrington, R. C. 1860. Descriptions of a singular appearance seen in the sun on September 1, 1859. *Monthly Notices of the Royal Astronomical Society* 20: 13–15.

Chapman, Sydney. 1968. Historical introduction to aurora and magnetic storms. *The Birkeland Symposium on Aurora and Magnetic Storms*. A. Egeland and J. Holtet, ed., pp. 21–29. Paris: Centre national de la recherche scientifique.

————. 1964. Solar Plasma, *Geomagnetism and Aurora*. New York: Gordon and Breach.

Chapman, Sydney, and Bartels, Julius. 1962. *Geomagnetism*, vol 2. Oxford: Clarendon Press.

Cunningham, Andrew, and Jardine, Nicholas. 1990. *Romanticism and the Sciences*. Cambridge: University of Cambridge Press.

Devik, Olaf. 1968. Kristian Birkeland as I knew him. *The Birkeland Symposium on Aurora and Magnetic Storms*. A. Egeland and J. Holtet, ed., pp. 13–19. Paris: Centre national de la recherche scientifique.

Goldman, Martin. 1983. *The Demon in the Aether: the story of James Clerk Maxwell*. Edinburgh: Paul Harris.

Hall, Captain Charles Francis. 1865. *Life with the Esquimaux: a narrative of Arctic experience in search of survivors of Sir John Franklin's expedition*. London: Sampson Low, Son, and Marston.

Harman, P. M. 1982. *Energy, Force and Matter*. Cambridge: Cambridge University Press.

Humboldt, Alexander von. 1860. *Cosmos: a sketch of a physical description of the universe*. New York: Harper & Brothers.

Kellner, L. 1963. *Alexander von Humboldt*. London: Oxford University Press.

King, Harry. 1982. *South Pole Odyssey: selections from the Antarctic diaries of Edward Wilson*. Poole, Dorset: Blandford Press.

Knight, David. 1986. *The Age of Science: the scientific world view in the nineteenth century*. Oxford: Basil Blackwell.

Lindroth, Sten. 1952. *Swedish Men of Science 1650–1950*. Stockholm: The Swedish Institute.

Meade, Marion. 1980. *Madame Blavatsky: the woman behind the myth*. New York: Putnam.

Nansen, Fridtjof. 1897. *Farthest North: the Norwegian polar expedition 1893–1896*, vol 1. Westminster: Archibald Constable.

Nordenskiold, A.E. 1883. *The Voyage of the Vega round Asia and Europe*. London: Macmillan.

Payer, Julius. 1876. *New Lands Within the Arctic Circle*. London: Macmillan.

Pratt, Mary Louise. 1992. *Imperial Eyes: travel writing and transculturation*. London: Routledge.

Roberts, Gail. 1973. *The Atlas of Discovery*. London: Aldus.

Ross, Sir James Clark. 1847. *A Voyage of Discovery and Research in the Southern and Antarctic Regions, During the Years 1839–43*. London: John Murray.

Schuster, Sir Arthur. 1975 [1911]. *The Progress of Physics*. New York: Arno Press.

Simpson, Frank A., ed. 1952. *The Antarctic Today: a mid-century survey by the New Zealand Antarctic Society*. Wellington: A. H. and A. W. Reed.

Stefansson, Vilhjalmur. 1944. *The Friendly Arctic: the story of five years in polar regions*. New York: Macmillan.

Störmer, Carl. 1955. *The Polar Aurora*. Oxford: Clarendon Press.

Tromholt, Sophus. 1885. *Under the Rays of the Aurora Borealis: in the land of the Lapps and Kvæns*. Boston: Houghton Mifflin.

Walton, D. W. H., ed. 1987. *Antarctic Science*. Cambridge: Cambridge University Press.

Wilson, Edward. 1966. *Diary of the Discovery Expedition to the Antarctic Regions 1901–1904*. London: Blandford Press.

CHAPTERS 5 AND 6

Akasofu, Syun-Ichi. 1992a. Aurora. *Encyclopedia of Physical Science and Technology*, 2d ed., vol. 2. Ed. Robert A. Meyers, pp. 403–15. New York: Academic Press.

————. 1992b. What causes the aurora. *Eos* 73: 209.

————. 1989. The dynamic aurora. *Scientific American* 260 (5): 90–97.

————. 1965. The aurora. *Scientific American* 236: 55–62.

Akasofu, Syun-Ichi, et al., ed. 1968. *Sydney Chapman, eighty from his friends*. Privately published.

Akasofu, S.-I., and Kamid, Y., ed. 1987. *The Solar Wind and the Earth*. Tokyo: Terra Scientific Publishing.

Alfvén, Hannes. 1986. The plasma universe. *Physics Today* (September): 22–27.

Becker, Robert O. 1990. *Cross Currents: the promise of electromedicine, the perils of electropollution*. Los Angeles: Jeremy P. Tarcher.

Becker, R. O., and Marino, A. A. 1982. *Electromagnetism and Life*. Albany: State University of New York Press.

Becker, R. O., and Selden, G. 1985. *The Body Electric*. New York: William Morrow.

Bond, F. R. 1990. Background to the aurora australis. ANARE (Australian National Antarctic Research Expeditions) Reports No. 135.

Brekke, Asgeir. 1984. On the evolution in history of the concept of the auroral oval. *Eos* 65: 705.

Brodeur, Paul. 1989. *Currents of Death: power lines, computer terminals, and the attempt to cover up their threat to your health*. New York: Simon Schuster.

Brown, Frank A., Jr. 1972. The "clocks" timing biological rhythms. *American Scientist* (60): 756–66.

Chapman, Sydney. 1958. Fredrik Carl Mülertz Störmer, 1874–1957. *Royal Society of London, Biographical Memoirs* 4: 257–79.

Dessler, A. J. 1970. Nobel Prizes: 1970— Swedish iconclast recognized after many years of rejection and obscurity. *Science* 170: 604–6.

————— 1967. Solar wind and the interplanetary magnetic field. *Reviews of Geophysics* 5: 1–7.

Dubrov, A. P. 1978 [1974]. *The Geomagnetic Field and Life: geomagnetobiology*. Translated from Russian by Frank L. Sinclair. New York: Plenum Press.

Feldstein, Y. I. 1986. A quarter of a century with the auroral oval. *Eos* 67: 761.

Fiala, Anthony. 1907. *The Ziegler Polar Expedition, 1903–1905*. Washington, D.C.: National Geographic.

Finney, John W. 1962. Mariner 2 data disclose a constant "solar wind." *New York Times*, October 11: 1, 15.

Hones, Edward W., Jr. 1986. The earth's magnetotail. *Scientific American* 254 (3): 40–47.

Hufbauer, Karl. 1991. Exploring the Sun: solar science since Galileo. Baltimore: Johns Hopkins University Press.

Jacobs, J. A., ed. 1989, 1991. *Geomagnetism*. vols. 3 and 4. San Diego: Academic Press.

Jaroff, Leon. 1989. Fury on the sun. *Time* 134 (1): 36–42.

Joselyn, Jo Ann. 1992. The impact of solar flares and magnetic storms on humans, *Eos* 73 (7): 81–82.

Kappenman, John G., and Albertson, Vernon D. 1990. Bracing for the geomagnetic storms. *IEEE Spectrum* 27 (3): 27–33.

Knox, T.W. 1885. *The Voyage of the Vivian to the North Pole and Beyond*. New York: Harper.

König, Herbert L., et al. 1981. *Biologic Effects of Environmental Electromagnetism*. New York: Springer-Verlag.

Lemström, S. 1886. *L'Aurore Boréale*. Paris: Gauthier-Villars.

McDougall, Walter A. 1985. . . . *the Heavens and the Earth: a political history of the space age*. New York: Basic Books.

Marino, Andrew A. 1988. *Modern Bioelectricity*. New York: Marcel Dekker.

Mawson, Douglas. 1925. *Australasian Antarctic Expedition 1911–14*. Scientific Reports, Series B., vol. II, part 1, Records of the aurora polaris.

Meng, Ching-I., et al., ed. 1991. *Auroral Physics*. Cambridge: Cambridge University Press.

Morgan, Nina. 1989. Inside science: the earth's magnetic field. *New Scientist* 23 (September): 1–4.

Noyes, Robert W. 1982. *The Sun, Our Star*. Cambridge, Mass.: Harvard University Press.

Nygrén, Tuomo, and Silén, Johan. 1982. A. E. Nordenskiöld and the auroral oval. *Eos* 63: 553.

Parkinson, W. D. 1983. *Introduction to Geomagnetism*. Edinburgh: Scottish Academic Press.

Persinger, Michael A. 1974. *ELF and VLF Electromagnetic Field Effects*. New York: Plenum Press.

Potemra, Thomas A., ed. 1984. *Magnetospheric Currents*. American Geophysical Union Monograph 28.

Presman, A. S. 1970. *Electromagnetic Fields and Life*. New York: Plenum Press.

Scientific Committee on Solar-Terrestrial Physics (SCOSTEP). 1988. *Solar-Terrestrial Energy Program: major scientific problems*. Proceedings of a SCOSTEP symposium, Helsinki University of Technology, Espoo, Finland.

Sulman, Felix Gad. 1980. *The Effect of Air Ionization, Electric Fields, Atmospherics and other Electric Phenomena on Man and Animal*. Springfield, ll.: Charles C. Thomas.

van Allen, James A. 1983. *The Origins of Magnetospheric Physics*. Washington, D.C.: Smithsonian Institution Press.

INDEX

A

Abbott, W. N., 115
Abduction by the aurora, 38, 40
Aborigine mythology, 26
Aeschylus, 47
Akasofu, Syun-Ichi, 124
Alaska, 9, 13, 14, 16, 21, 25, 31, 33, 90, 124
Alfvén, Hannes, 107, 110
All-sky photographs, 123, 124
Anaxagoras, 47, 48, 60
Anaximenes, 45, 47
Angot, Alfred, 37
Animal mythology, 25
Antarctic exploration, 76, 77, 79, 96
Antarctica, 14, 26, 50, 64, 96, 126
Aqatsiaq, Suzanne Niviattian, 35

as weather, 49, 62-63, 83
Aurora australis, 14, 15, 16, 26, 35, 50, 73, 76, 79, 96, 112, 115. *See also* Antarctica; Australia; New Zealand; individual subject headings
"Aurora Borealis," 69
"Aurora Borealis Decapitating a Young Man, The," 41
Aurora borealis, defined, 13, 52. *See also* Auroral ovals; Canada; Germany; Great Britain; Russia; Scandinavia; United States; individual subject headings
Auroral breakup, 124
Auroral classification, 22, 117, 119, 122, 124
Auroral colours, 119-20, 122
Auroral conjugacy, 14, 76, 117

Battle, 33, 37, 39, 54
Becker, Robert O., 30, 130
Bering Strait, 75
Biological effects of aurora, 130. *See also* Healing; Heart ailments
Biot, Jean-Baptiste, 72
Birkeland currents, 94, 98, 99, 107, 117, 119
Birkeland, Kristian, 90, 93-94, 98-99, 100, 107, 110, 124
Blavatsky, Madame Helena Petrovna, 87
Blood, 33, 35, 37
Blood stones, 37
Blue-violet auroras, 122
Blunt Horn, John, 31
Boreale aurora, 52
Bossekop, Norway, 95

Arago, François, 69
Arcs, 22, 90, 126
Arctic exploration, 28, 75, 77, 78
Aristotle, 45, 47-48, 49, 60
Arrowmaker, Alexis, 28
Artificial auroras, 54, 94
Assikinack, Francis, 32
Atmosphere. *See* Ionosphere
Auckland, New Zealand, 17
Aurora
 as angel light, 87
 as battle, 33, 37, 39, 54
 as blood, 33, 35, 37
 as dance, 25
 as electrical, 62-64, 77
 as electromagnetic, 84, 88-90, 93*ff*, 115*ff*
 as evil portent, 37-38
 as fertile power, 28, 33, 35
 as football, 28
 as healing power, 28, 31
 as ice, 47, 50
 as magnetic, 58-60, 71, 81-84
 as radium mine, 101
 as reflected light, 26, 28, 47, 50, 52, 58
 as solar atmosphere, 47, 60-62
 as spirits of animals, 25
 as spirits of the dead, 32-33
 as spirits of women, 28
 as vapours, 45, 47, 48, 52, 54, 58

Auroral currents, 103, 107. *See also* Auroral electrojets; Birkeland currents; Ring currents
Auroral cycles, 18, 49, 81-83, 94, 99, 127, 129
"Auroral Daughters, The," 28
Auroral electrojets, 130
Auroral forms, 22, 117, 119, 122, 124
Auroral glories, 122
Auroral heights, 14, 53, 100, 119, 120
Auroral movements, 122
Auroral observation, 16-17, 18, 21, 79, 111, 122, 123
Auroral ovals, 14, 15, 16, 122, 123, 124, 126, 127, 129
Auroral photography, 100, 101, 123, 124, 126
Auroral sound, 37, 53, 54
Auroral speed, 125
Auroral substorms, 124, 125, 127, 129, 130
Auroral zone, 14, 79, 122
Australia, 14, 17, 26, 81, 82

B

Baffin Island, Northwest Territories, 78
"Ballad of the Northern Lights, The," 101
Bamberg, Germany, 39
Bands, 22, 23
Barrow, Alaska, 16

Brahe, Tycho, 48, 52
Braun, Werner von. *See* von Braun, Werner
Breakup, 124
Bret, 26
British Astronomical Association, 111
British folklore, 25, 37
Brown, Frank A., 130

C

Canada, 13, 14, 16, 53, 78, 81, 101, 107, 109, 111, 126
Canadian folklore, 25, 28, 31, 32, 33, 38, 40, 41, 42, 53
Cape of Good Hope, 81
Carrington, Richard, 82
Cathode rays, 93. *See also* Electrons
Celsius, Anders, 15, 59, 72
Chapman, Sydney, 99, 103, 107
Chasms and chasmata, 48
Childbirth, 28, 33, 35
Chinese mythology, 28, 33
Christiania, Norway, 90
Chugach National Park, Alaska, 21
Chukchi mythology, 33
Church, Frederic Edwin, 69
Churchill, Manitoba, 13, 107, 109
Chuvash mythology, 28
Classification, 22
Closed field lines, 103

Clouds. *See* Noctilucent clouds; Weather
Colours, 119-20, 122
Conjugacy, 14, 76, 117
Cook, Captain, 76
Copenhagen, Denmark, 56, 84
Copernicus, 52
Coppermine, Northwest Territories, 16
Copper River Delta, Alaska, 90
Corona, 22, 42, 61, 130
Coronal holes, 127, 130
Crookes, Sir William, 93
Cycles, 18, 49, 81-83, 94, 99, 127, 129

D
Dalton, John, 60
Darwin, Charles, 69
Davidialuk Alasua Amittu, 41
Davis, C. H., 31
Dawson, Yukon, 101
Dead hand, 26
Death, 32-33
Decapitation by the aurora, 38, 41
de Mairan, Jean Jacques d'Ortous, 60-62, 64
Dene mythology, 28, 32, 40
Descartes, René, 15, 52, 53, 54
Diameter. *See* Auroral ovals
Diffuse aurora, 124
Dimensions. *See* Auroral heights; Auroral
 ovals
Discovery, 115
Discrete aurora, 124
Dogrib mythology, 32
Doody, Jerry, 101
Dream Circles, 26
Dynamics Explorer, 15, 123, 125,126
Dynamo, 84. *See also* Magnetospheric
 generator

E
Earth magnetism. *See* Geomagnetic field
Edinburgh, Scotland, 16
Einstein, Albert, 13, 87, 93
Electrical power generation, 84, 116, 117,
 118, 129, 130
Electrical theories, 62-63, 77
Electrojets, 130
Electromagnetic induction, 84, 94, 103, 116.
 See also Electrical power generation
Electromagnetic theories, 84, 88-90, 93*ff*,
 115*ff*
Electromagnetism, 84
Electron accelerator, 119, 129
Electrons, 15, 93-94, 98, 103, 117, 119, 120,
 122, 124, 127
Eleven-year cycle, 18, 49, 81-83, 129

Equinoxes, 18, 127
Eskimo mythology, 25, 28, 31, 33, 35
ESP, 33
Estonian folklore, 28
Euler, Leonhard, 62
Eureka, Northwest Territories, 126
Excitation, 119, 120
Expansion phase, 124
Explorer 12, 110
Explorer 14, 110
Ezekiel, 45, 47

F
Fairbanks, Alaska, 14
Fairy blood, 37
Faraday, Michael, 84, 99, 116
Feldstein, Yasha, 123
Ferris, Timothy, 48
Fertility, 28, 33, 35
Field-aligned currents, 94, 98, 99, 107, 117,
 119
Field theory, 84
Finland, 22, 88, 89, 94
Finnish folklore, 25, 28, 37
Fire foxes, 25
First Polar Year, 89
Fishing, 28
Flares. *See* Solar flares
Forecasts, 21
Forms. *See* Auroral forms
Forster, Georg, 76
Fram, 78, 81
Franklin, Benjamin, 15, 62-64
Franz Josef Land, 75, 106
Fred's auroral nursery, 118
French-Canadian folklore, 25, 28, 38, 42
Friedman, Howard, 30

G
Galilei, Galileo, 15, 52, 60
Gas-discharge tubes, 64, 84, 89, 93, 94
Gauss, Carl, 73, 81
Gay-Lussac, Louis, 69, 72
Gemma, 48
Geomagnetic disturbances. *See* Magnetic
 disturbances
Geomagnetic field, 15, 21, 58-59, 71, 72, 73,
 81, 94, 102, 103, 104, 110, 115, 116, 117,
 124. *See also* Magnetic declination;
 Magnetic disturbances; Magnetosphere;
 Magnetotail
Germany, 16, 39, 72, 73, 81, 82
Gilbert, William, 59, 103
Goose Bay, Labrador, 16
Great Britain, 16, 25, 37, 54, 71, 82, 84,

93, 111
Great red auroras. *See* Red auroras
Great Slave Lake, Northwest Territories, 13
Green auroras, 119
Greenland, 33
Gwich'in mythology, 40, 42

H
Hall, Charles Francis, 78, 86
Halley, Edmond, 15, 54, 58-59, 62, 71
Hawkins Island, Alaska, 13
Healing, 28, 31
Heart ailments, 30, 31, 42
Hebrides folklore, 25, 37
Height, 14, 53,100, 119, 120
Hel, 33
Helsinki, Finland, 89
Henry of Huntingdon, 37
Hervarar Saga, 33
Hiorter, Olof, 59, 72
Hippocrates of Chios, 47, 50
Holmberg, Uno, 33
Homogeneous bands, 22
Humboldt, Alexander von. *See* von
 Humboldt, Alexander
Hunting, 28
Hydro Quebec, 130

I
Iceland, 94, 111
Igloolik, Northwest Territories, 35
Induction, 84, 94, 103, 116
Interference caused by aurora, 82, 111, 130
International Geophysical Year, 123
Inuit mythology, 25, 28, 31, 41, 53. *See also*
 Eskimo mythology; Sami mythology
Ionosphere, 14, 94, 102, 107, 110, 117, 119,
 120, 122, 130
Iron, for repelling aurora, 26
Iroquois mythology, 33
Italy, 16, 37, 73
Ithenhiela, 32

J
Japan, 14, 16
Japanese folklore, 28
Jeremiah, 47
Jupiter, 115

K
K index, 21
Kaurna mythology, 26
Kelvin, Lord, 98
King's Mirror, The, 50
Kirill, 32

Knik Valley, Alaska, 9
Knox, T.W., 118
Kodiak Island, Alaska, 31
Kurnai mythology, 26

L
Lakota Sioux mythology, 28, 31-32
Langley, Samuel Pierpoint, 98
La Ronge, Saskatchewan, 16
Leaky-bucket theory, 124, 127
Lemström, Karl Selim, 84, 88, 94
Lightning, 62
Little Ice Age, 49
Location. See Auroral zone
Lomonosov, Mikhail Vailievich, 64
London, England, 37, 54, 71, 82, 84
Los Angeles, California, 16
Lycosthenes, 45

M
McDougall, Walter A., 109
Madness, 30, 42
Magnetic crusade, 81
Magnetic declination, 58, 71
Magnetic disturbances, 21, 30, 59, 71, 75, 99,
 130. See also Magnetic storms
Magnetic field, earth's. See Geomagnetic
 field
Magnetic fields, 84
Magnetic observatories, 72-73, 77, 81
Magnetic storms, 71, 72, 73, 82, 83, 94, 98,
 111, 128, 130. See also Magnetic
 disturbances
Magnetic substorms, 130
Magnetic theories, 58-60, 71, 81-84. See also
 Electromagnetic theories
Magnetohydrodynamic generator, 118
Magnetosphere, 107, 110, 119, 122. See also
 Geomagnetic field; Magnetotail
Magnetospheric generator, 116, 117, 118,
 129
Magnetotail, 103, 115, 116, 117, 124, 127.
 See also Geomagnetic field; Magnetosphere
Main field, 71, 73
Manitoulin Island, Ontario, 32
Maori mythology, 26
Mariner 2, 110
Marino, A. A., 130
"Marionettes," 28
Massola, Aldo, 26
Maunder, Edward, 82, 99
Maunder Minimum, 49, 54
Mawson, Douglas, 96
Maxwell, James Clerk, 69
"Merry dancers," 25

MHD generator. See Magnetospheric generator
Middle Ages, 37, 50
Mitchell, Catherine, 40
Mittelwerk, 109
Moon, 18, 115
Moscow, Russia, 16
Mungan Ngour, 26
Munich, Germany, 16
Munthe, Gerhard, 28

N
Nanahboohzho, 32
Nansen, Fridtjof, 78, 81
Neptune, 115
Newton, Isaac, 54, 64, 82
New Zealand, 17, 26, 111
"Nimble men," 25
Nitrogen, 119, 122
Nobel Prize, 110
Noctilucent clouds, 111
Nordenskiold, Adolf E., 75, 77
Nordvik, Russia, 16
Northern lights. See Aurora borealis
Northumberland, England, 37
Northwest Passage, 77
Norway, 16, 90, 95
Norwegian folklore, 38
Novaya Zemlya, 94
Novgorod, Russia, 32
Nunamiut Eskimo mythology, 28

O
Observatories. See Magnetic observatories
Observing the aurora, 16, 17, 18, 21, 111,
 122, 123
Oersted, Hans Christian, 84
Open field lines, 103
Oslo, Norway, 16
Ottawa mythology, 32
Oval, auroral. See Auroral ovals
Oxygen, 119, 120, 129

P
Paris, France, 16, 37, 62, 72
Parry, William Edward, 77
Patches, 16
Pearl Harbor, 37
Photography, 100, 101, 123, 124, 126
Piezo-electricity, 53
Pink auroras, 122
Plasma, 102, 103, 110, 115, 116, 122, 127,
 128, 129. See also Solar wind
Pliny the Elder, 37
Poker Flats, Alaska, 14
Polar cap aurora, 126

Polka, 25
Portents, 37-38
Power blackout, 130
Power output of the aurora, 117, 118
Prediction services, 21
Primary electrons, 120
Prince William Sound, Alaska, 13
Prominences. See Solar prominences
Protons, 15, 103, 104, 117
Psychiatric admissions, 30
Pulsing auroras, 21, 22, 25, 124
Pushkin, 64, 72

R
Radio interference, 111, 130
Radio waves, 53
Ramindjeri mythology, 26
Rasmussen, Knud, 28
Rayed bands, 22
Rays, 12, 22, 124
Recovery phase, 124
Red auroras, 22, 37, 64, 120, 129
Reflected light, 26, 28, 47, 50, 52, 58
Ring currents, 103, 130
Rocketry, 107, 109
Rome, Italy, 16, 37
Ross, James Clark, 77, 81
Ross, John, 77
Royal Astronomical Society of New Zealand,
 111
Russell, Annie S. D., 82
Russia (U.S.S.R.), 14, 16, 32, 33, 64, 72-73,
 109

S
Sabine, Edward, 73, 77, 81-82
Sagan, Carl, 47
St. Petersburg, Russia, 64, 72-73
Sami mythology, 28, 33, 37
Saskatoon, Saskatchewan, 16
Satellites, 15, 109-10, 123, 125, 126
Saturn, 115
Scandinavia, 14, 16, 22, 56, 73, 84, 88, 89,
 90, 94, 95, 107
Scandinavian folklore, 25, 28, 33, 37, 38
Schwabe, Samuel, 81
Scientific travellers, 69, 73, 76
Scott, Robert F., 79
Scott, Sir Walter, 25
Scottish folklore, 25, 37
Secondary electrons, 120
Service, Robert W., 101
Shamans, 28, 31-32
Siberia, 33, 72
Singing to the aurora, 38

Sioux mythology, 28, 31-32
Soccer, 33
Solar atmosphere, 47, 60, 61, 102, 107
Solar cycle, 129. *See also* Eleven-year cycle;
 Sunspots
Solar flares, 82, 98, 128, 130
Solar magnetism, 115-116, 127, 128, 129
Solar prominences, 128, 129
Solar wind, 103, 104, 115, 116, 122, 124,
 125, 127, 129, 130
Solar wind/magnetospheric generator, 116,
 117, 118, 129
Sound of aurora, 37, 53, 54
Sound to repel aurora, 38, 42
Southern lights. *See* Aurora australis
Space Environment Sciences Center, 21
Space shuttle, 115
Space travel, 35, 109. *See also* Rocketry;
 Satellites; Space shuttle
Spectroscopy, 89
Speed, 125
Spirit journeys, 31, 35
Spitsbergen, 94
Stockholm, Sweden, 107
Störmer, Carl, 99, 100
Substorms, 124, 125, 126, 127, 129, 130
Suicide, 33
Sun-aligned arcs, 126
Sun-earth generator, 116, 117, 118, 129
Sunlight, reflected, 28, 47, 52
Sunspots, 60, 81-82, 83, 93, 98, 127-29
Sweden, 73, 107
Swedish folklore, 25, 28
Sydney, Australia, 17

T
Tahu-nui-a-Rangi, 26
Tasmania, 81
Tegetthoff, 75
Telegraph, 82, 94
Terrestrial magnetic field. *See* Geomagnetic
 field
Theosophical Society, 87
Theta auroras, 126
Timing of aurora. *See* Auroral observation;
 Auroral cycles
Tokyo, Japan, 16
Toronto, Ontario, 81
Triangulation, 100
Triewald, Samuel von. *See* von Triewald,
 Samuel
Tromholt, Sophus, 89
Tromsø, Norway, 16
Tula, 76
Twenty-seven-day cycle, 18, 99, 127
Types of aurora, 22, 117, 119, 122, 124

U
United States, 14, 38, 53, 82, 109, 111, 117.
 See also Alaska
United States Army, 109
Upper atmosphere. *See* Ionosphere

V
V-2 rockets, 109
Valkyries, 28
Vapours, as cause of aurora, 45, 47, 48, 52,
 54, 58
Vaussenat, C. X., 88

Vega, 75
Veil, 22
Violet auroras, 122
Virgil, 120
von Braun, Werner, 107, 109
von Humboldt, Alexander, 15, 53, 69, 71,
 72-73, 76, 77, 81, 123
von Triewald, Samuel, 54

W
War, 33, 37, 39, 54
Weather, 49, 62-63, 83
Weber, Wilhelm, 73
Wedding, 28
Westward-travelling surge, 124, 125
Whistling at the aurora, 38, 40
Whitman, Walt, 115
Whymper, Frederick, 47
Wilcke, Johann Carl, 60
Women, spirits of, 28
World War II, 37, 107, 109

Y
Yellowknife, Northwest Territories, 16
Yukon River, Alaska, 25

Z
Zodiacal light, 60